CONTEMPORARY AMERICAN
Women Artists

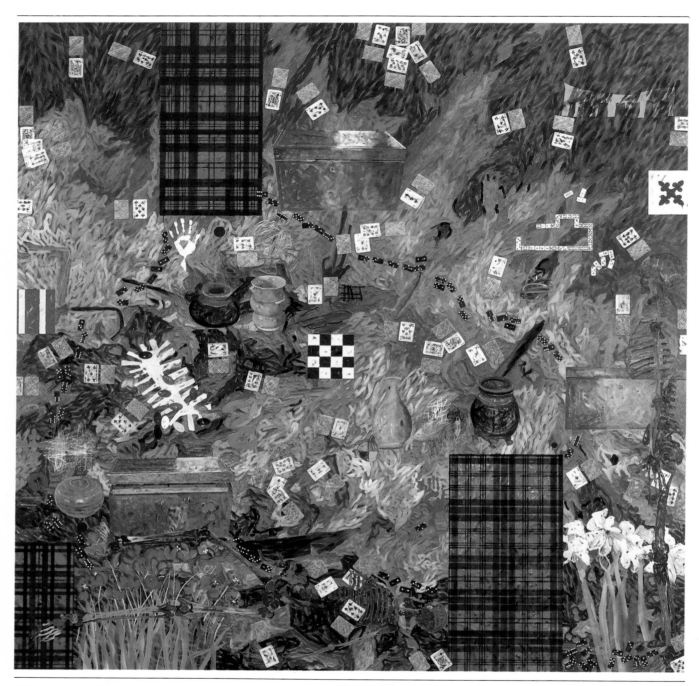

Palace of the Babies, 1990
Jennifer Bartlett
Oil on canvas, 10 x 10 ft.
Photo, ©James Dee
Courtesy, Paula Cooper Gallery, New York

CONTEMPORARY AMERICAN

Women Artists

Cedco

Cedco Publishing Company
2955 Kerner Blvd.
San Rafael, CA 94901

First Edition

This book published by Cedco Publishing Company
2955 Kerner Blvd., San Rafael, CA 94901

Printed in Korea

ISBN 1-55912-252-8

Acknowledgments

Cedco Publishing would like to extend appreciation to the artists and galleries represented in this book whose cooperation and assistance has made Contemporary American Women Artists *a reality.*

In addition we would like to thank the selection committee members for generously giving their time on such short notice. Their expertise was invaluable in compiling the list of artists represented herein.

In closing we would like to thank specific members of the book production team. Mary Sullivan served as liaison between the selection committee, artists and galleries as well as securing all rights and permissions to use the works of art shown in this book. Donald Scott Macdonald designed the book and supervised production. Wendy L. Goldberg, a woman artist herself, assisted in all aspects of production. Julie Simpson synthesized and revised the writing of numerous and stylistically diverse articles, manuscripts, biographies, etc. submitted by the artists and galleries. Robert Young initiated and managed schedules, in addition he critiqued, edited and finalized all written text. Mary K. Smith organized and coordinated text copy and photography in conjunction with typesetting schedules. A special thank you to the publisher, Charles E. Ditlefsen, who saw the need for this book and made its creation possible.

CONTENTS

Gently, 1982
Joan Mitchell
Oil on canvas, 21½ x 18 in.
Photo, ©Zindman/Freemont
Courtesy, Robert Miller Gallery, New York

Introduction

Although there have always been outstanding women artists in America, a book like *Contemporary American Women Artists* would not have been well-received twenty-five years ago. During these years there have been changes in the perceptions, attitudes and possibilities that have signaled a shift for women artists from a peripheral role in contemporary art to one of full participation and undeniable influence.

There are so many women artists in the art mainstream that it would be impossible to include more than just a few of those who have made important contributions. This book focusses on a select group of American artists whose work reflects a broad spectrum of aesthetic, social and political concerns, not to mention mediums, styles and subject matter.

As might be expected the selection of the artists included in this book was a difficult one. This process involved research about and review of the work of hundreds of women artists by a committee of six art professionals who made the final selection recommendations.

The artists included in this book such as Miriam Schapiro, Jennifer Bartlett and Janet Fish are among a legion of women whose works are admired by an awakened public. Still, times and minds change slowly and a limited awareness of the work by women artists still exists.

In *Contemporary American Women Artists* you will enter into the lives and view the works of twenty-four dedicated artists who are painting, sculpting, carving and otherwise creating a place in the modern art world. We hope that you will enjoy the works of these talented women.

Jennifer Bartlett

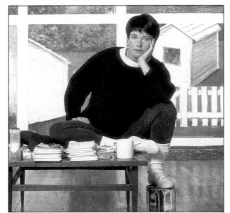

"I have the sort of mind that has to do several things at once. But I call myself a painter, and that's where the real emotional attachment is."

Jennifer Bartlett does not work small. Her works are often made of many parts and are painted with mathematical precision. She is given to large scale thinking. One work, "Rhapsody," has squares of flat enamelled steel upon which she has explored the universe of colors, textures and forms.

Bartlett feels that her best ideas always come out of the actual process of working. Her method involves a great deal of physical work, a "labor intensive" method unencumbered by wooden stretchers or even canvas. Rather, she has settled for working directly on steel plates coated with a layer of baked-on white enamel.

Her work is lavish in scale and decoration. Bartlett takes a subject and studies it thoroughly. For instance, when staying in France, she did a "study" of a little garden, which she said she didn't even like, and produced a series of two hundred drawings in ten different media. Many of these drawings were done in pairs, with the more figurative one on the left and the more abstract on the right. She seems to be saying, "look at this garden long enough and hard enough and you can find the world." There is a remarkable sense of self-discovery in an undertaking of this kind.

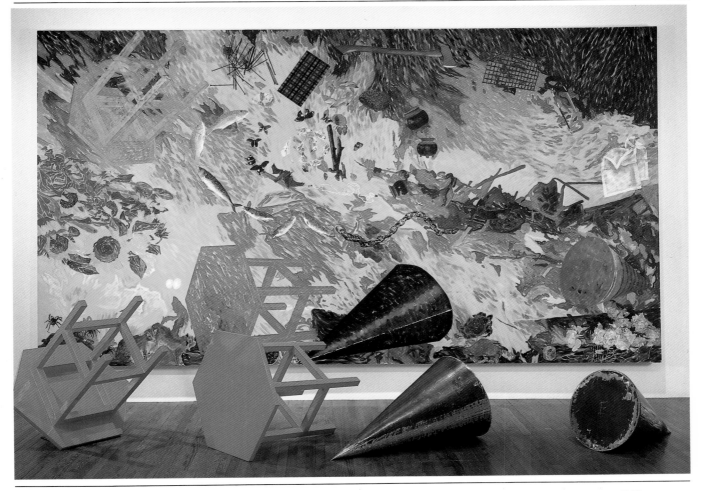

Spiral: An Ordinary Evening in New Haven, 1989
Painting: oil on canvas, 108 x 192 in.
 Tables: painted wood, 30½ x 32 x 35 in.
 painted wood and steel base, 39½ x 41 x 35 in.
 Cones: break formed hot rolled welded steel, 20 x 30¼ x
 21 and 22 x 42½ x 23 in.
Photo, ©Andrew Moore
Private Collection, New York
Courtesy, Paula Cooper Gallery, New York

Jennifer Bartlett

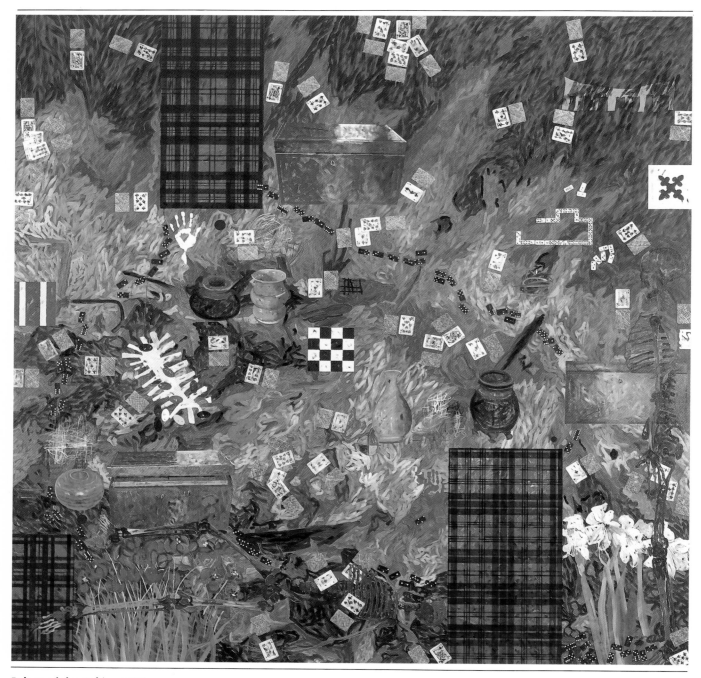

Palace of the Babies, 1990
Oil on canvas, 10 x 10 ft.
Photo, ©James Dee
Courtesy, Paula Cooper Gallery, New York

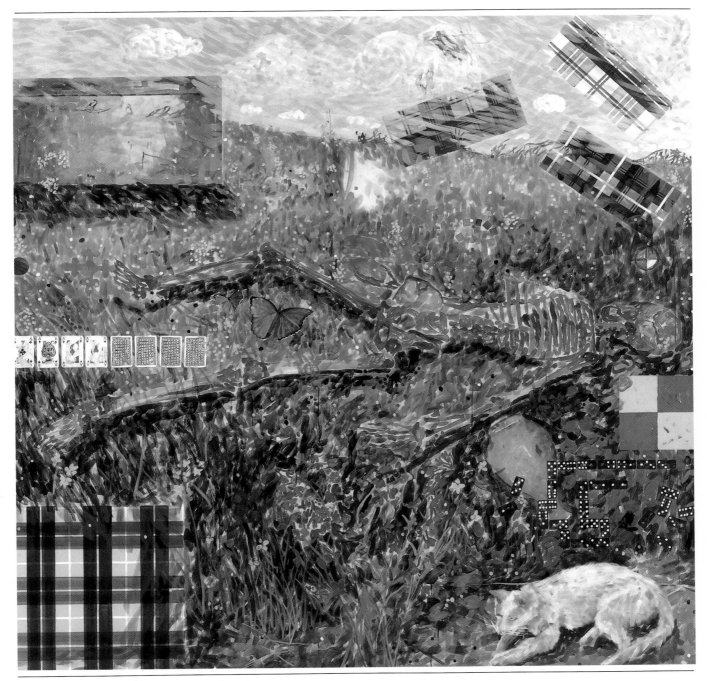

Summer, 1990
Oil on canvas, 6 x 6 ft.
Photo, ©1990 James Dee
Collection, Seibu Corporation, Tokyo
Courtesy, Paula Cooper Gallery, New York

Lynda Benglis

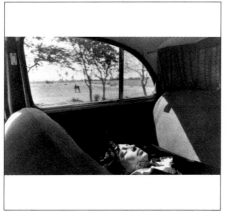

Photo, ©Lee Friedlander, 1989

"I named pieces after people (who didn't yet know the titles), and inevitably they would be drawn to the knots that related to them."

Lynda Benglis has participated in the art movements and issues of the day—from pop and minimalism to process and feminism. She is interested in bringing to each art style something personal and physical.

Her work is difficult to label as it often contradicts the rules of the prevailing art trends. Drawing from a wide range of materials to create her sculptures she has moved from one concept to another exploring the physical nature of her materials. She didn't want to be limited by stretched canvases and hard edges.

"I was truly interested in where painting could go," Benglis stated. "I used polyurethane and called it paint. I built up sculptures with pure matter." In some of her works she used poured latex and polyurethane foam, often pigmented in day-glo colors, making monumental pieces that seemed to ooze off the wall or hover above the floor like freeze-frame lava flows. Additionally, she works with materials such as wire mesh, stiffened bunting, aluminum foil and tin, knotted or manipulated into organic forms. In total Benglis' work attempts to return allusion to abstraction.

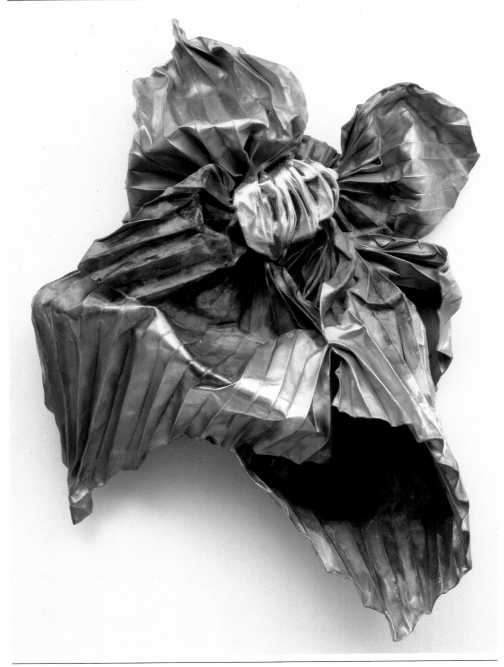

Morisse, 1985-87
Copper, nickel, chrome and gold leaf, 48 x 43 x 14 in.
Photo, © Geoffrey Clements
Collection, Armand Castellani, Buffalo, NY
Courtesy, Paula Cooper Gallery, New York

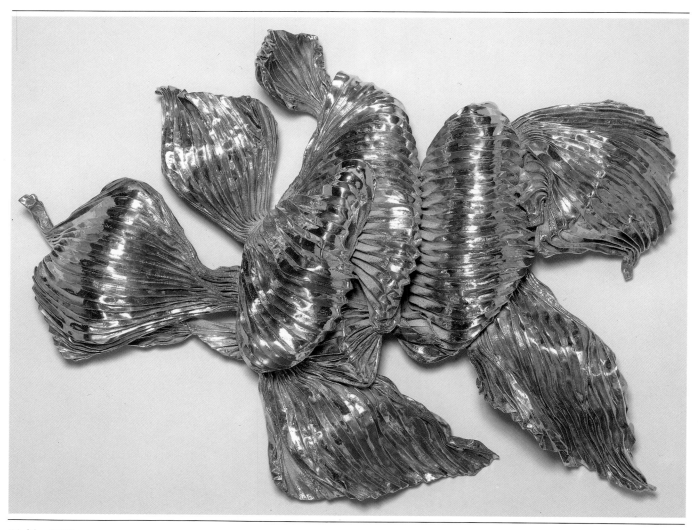

Diablo, 1990
Stainless steel mesh and aluminum, 68 x 92 x 21 in.
Photo, ©Douglas Parker
Courtesy, Paula Cooper Gallery, New York

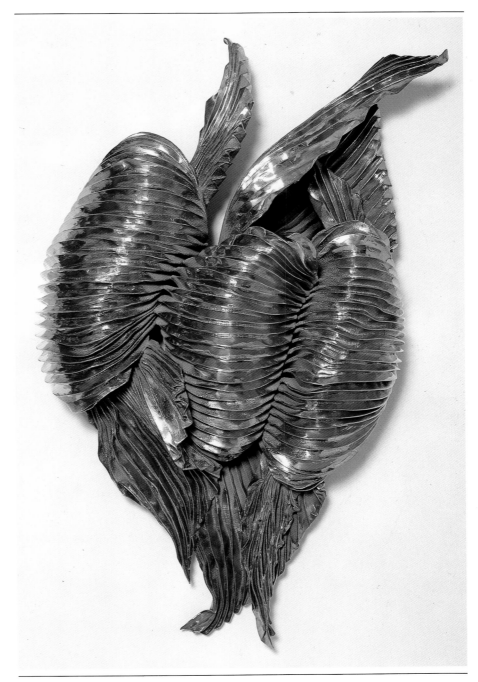

Panhard, 1989
Copper over stainless steel mesh, 72 x 39 x 18 in.
Courtesy, Margo Leavin Gallery, Los Angeles

Louise Bourgeois

Photo, Robert Mapplethorpe, 1982

"I am never literal. An artist can show things that other people are terrified of expressing."

In describing what the sculpting experience is for her, Louise Bourgeois has said, " . . . how will I seduce that stone and make it a work of art? I say 'seduce' because its resistance is total. But I am attracted to resistance."

At 79, Bourgeois work is as strong as ever. She has a indefatigable spirit that produces art of consistency and complexity. In pursuit of artistic expression, she has modeled, carved, designed and assembled art. She wants to be both tough and unsparing in her resistance to sentimentality and faithful to the turbulence of emotional life. Her work is profoundly anti-utopian. It suggests that human beings are predators who devour one another by seduction and power, or through the rigid societal and psychological constraints in which they live out their lives. According to Bourgeois, betrayal and anxiety are inevitable, and frustration impossible to relieve.

Her works which incorporate images of body parts as isolated shapes have an especially powerful impact. The work, "Untitled (With Hand)" bears the inscription, "I love you." These are key words in conversations that are used (often in vain) to bridge the lonely gap that separates all human individuals. The anonymity of the doll arm is a visual metaphor for this human dilemma.

Through her work, Bourgeois maintains a sense of hopefulness as she reflects upon the frustrations of life.

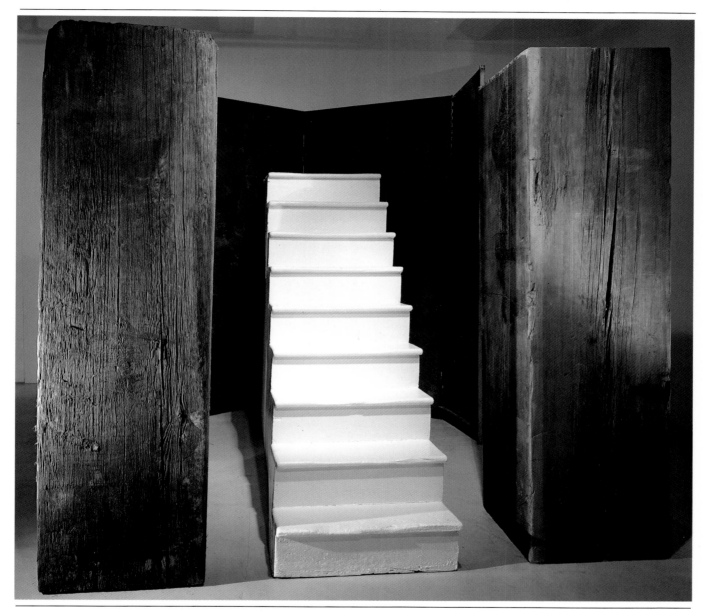

No Escape, 1989
Wood and metal, 96 x 99 x 120 in.
Private Collection
Photo, ©Peter Bellamy
Courtesy, Robert Miller Gallery, New York

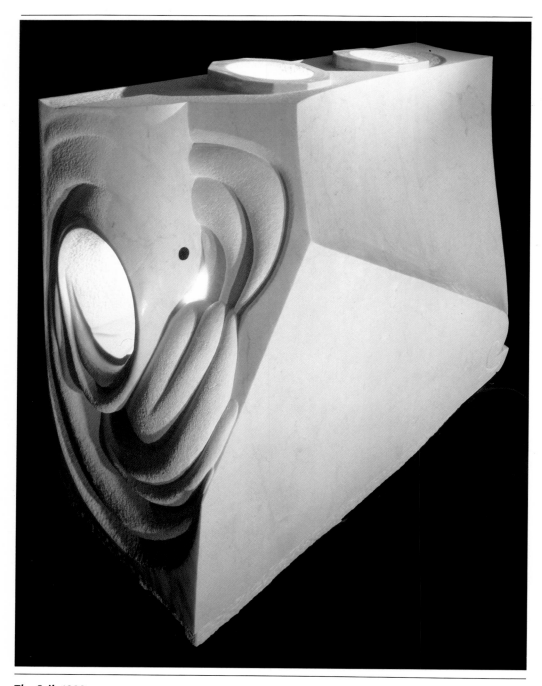

The Sail, 1988
Marble, 60 x 30 x 70 in.
Photo, ©Peter Bellamy
Courtesy, Robert Miller Gallery, New York

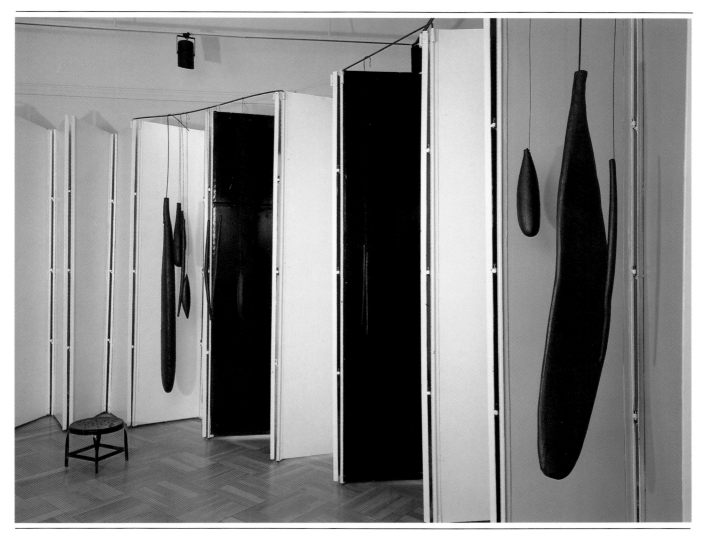

Articulated Lair, 1986
Painted steel and rubber with black stool, 132 in high
Photo, ©Peter Bellamy
Courtesy, Robert Miller Gallery, New York

Deborah Butterfield

"I first used the horse images as a metaphorical substitute for myself — it was a way of doing a self-portrait one step removed from the specificity of Deborah Butterfield. These first horses were huge plaster mares whose presence was extremely gentle and calm. They were at rest and in complete opposition to the raging warhorse (stallion) that represents most equine sculpture.

The next series of horses was made of mud and sticks and suggested that its forms were left clotted together after a river flooded and subsided. The pieces were dark and almost sinister, reflecting the realization that I was perhaps more like the warhorse than the quiet mares. For me they represented the process of attitudes and feelings taking shape after a flood of experiences. The materials and images were also meant to suggest that the horses were both figure and ground, merging external world with the subject.

The more recent horses incorporate found materials, all having their own history and diverse visual qualities. Often finding the right material when you need it is next to impossible and fate tends to determine what you will find and when. I always work to make the personality of each horse dominate and overrule the identity of its sum parts. These horses are really hollow shells, but are built-up from within and reveal the interior space. The gesture is contained and internalized while the posture is quiet and still. Action becomes anticipated rather than captured. Each horse represents a framework or presence which defines a specific energy at a precise moment.

I ride and school my own horses (and am schooled with them!) and feel that my art relies heavily upon, and often parallels, my continuing dialogue with them. I am more and more interested in how each horse thinks, and hope that my work begins to feel more like horses than even to look like them."

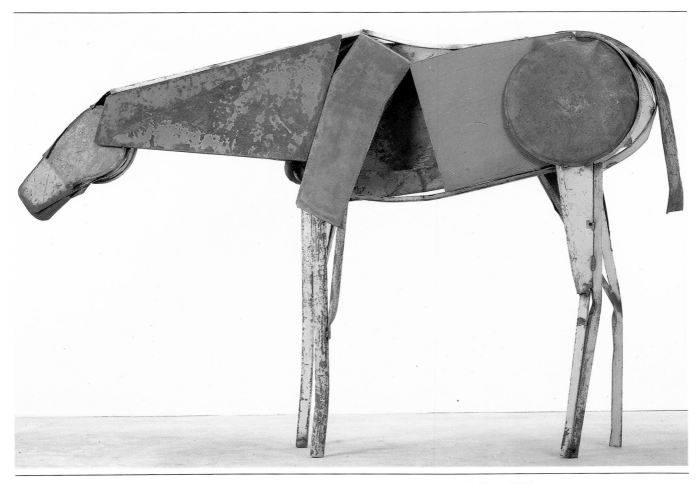

Palma, 1990
Found steel, 77 x 119 x 26 in.
Courtesy, Edward Thorp Gallery, New York

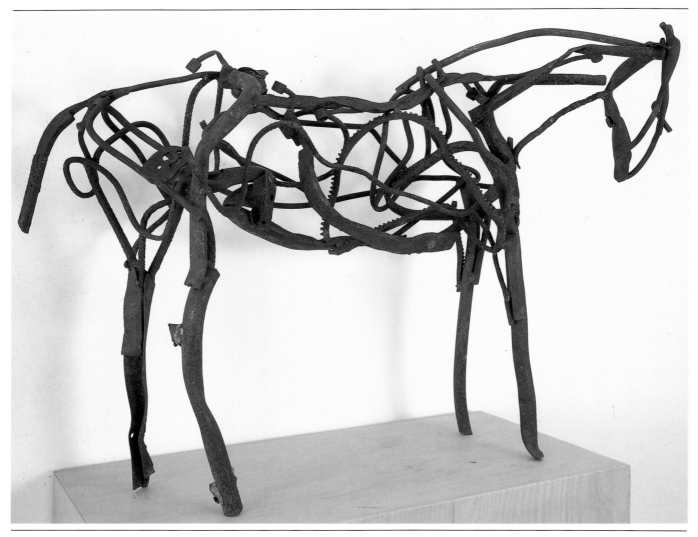

Tango, 1987
Steel, 28½ x 42 x 15 in.
Courtesy, Edward Thorp Gallery, New York

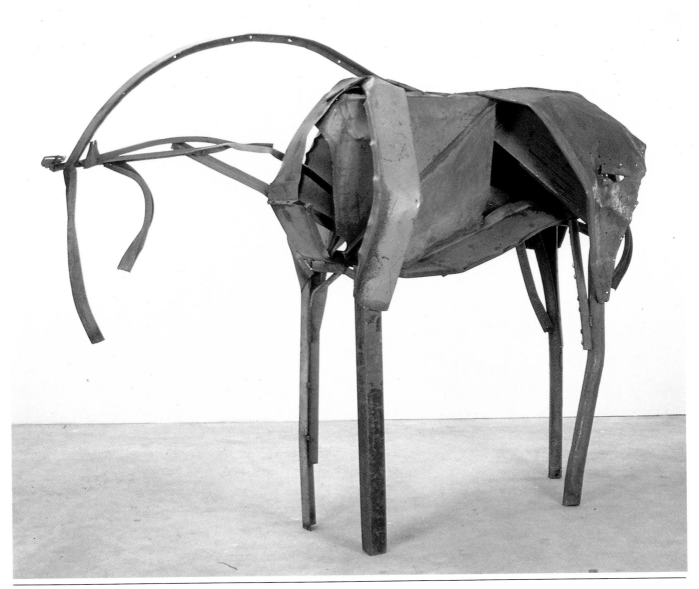

Verde, 1990
Found steel, 79 x 108 x 31 in.
Courtesy, Edward Thorp Gallery, New York

Louisa Chase

Louisa Chase's work changed in the mid-nineteen eighties. Chase's previous work, hands, feet, trees and flowers were depicted by loose strokes of rich oil paint swirled around these objects.

Since then Chase has been making abstractions. Scribbled outlines in aggressive strokes of black with shadow lines of light blues and grays fill the white field of the canvas. Often a small, single colored, opaque, geometric, doll-like figure floats over the surface of the lined background. A larger transparent colored shadow figure appears behind separated from the small figure by the intervening abstract world. One figure seems the dream, the other dreamer; the question is, which one is which?

These works speak of the sense of self. The self as it relates to other people and other elements in life. For Chase, *self* and *world* are inextricable extensions of each other.

Headstand, 1990-91
Oil on canvas, 80 x 70 in.
Courtesy, Brooke Alexander, New York

Wirewalker, 1990-91
Oil on canvas, 80 x 70 in.
Courtesy, Brooke Alexander, New York

The Rape of the Sabine Women, 1990-91
Oil on canvas, 72 x 102 in.
Courtesy, Brooke Alexander, New York

Janet Fish

Photo, ©Jan Groover, 1984

"When I set up some-thing, I anticipate that I haven't really seen it until I start painting it."

Janet Fish, who likes to be referred to as a "perceptual realist," has the ability to give to the plain events and objects of ordinary life, a composed serenity, yet she embodies in them an inner motion that is furious.

Peaches and goblets, bottles and mirrors, books and lamps, television sets and typewriters, wallpaper, cats, friends, kites, sky, ponds, children—all seem to have been captured with their entire essence, energy and light.

To prepare for a still life, Fish gathers together compatible objects that have an intriguing color relationship. "I push shapes around and experiment for a few days on the object." Rather than mulling over an idea, she surrounds herself with the objects, contemplating their compositions and shapes. She has stated that there is an aspect about painting that is like meditation. "You sit there with something very quiet. You are looking at it all day and you are constantly pushing out through the thing you are looking at. Part of my reason for picking an object is to try to get past the limitations of my own mind by looking at things outside myself."

Arcanum, 1990
Oil on canvas 80 x 50 in.
Photo, © Phillips/Schwab
Courtesy, Robert Miller Gallery, New York

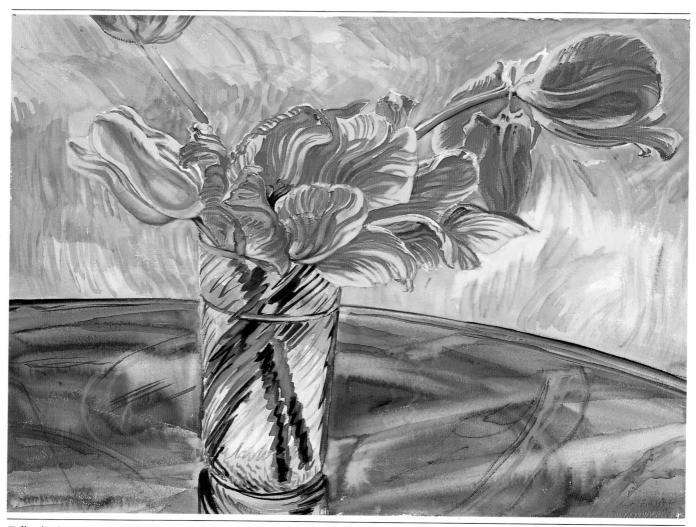

Tulips in Green Glass, 1990
Watercolor on paper, 22-1/2 x 29-1/2 in.
Photo, © Phillips/Schwab
Courtesy, Robert Miller Gallery, New York

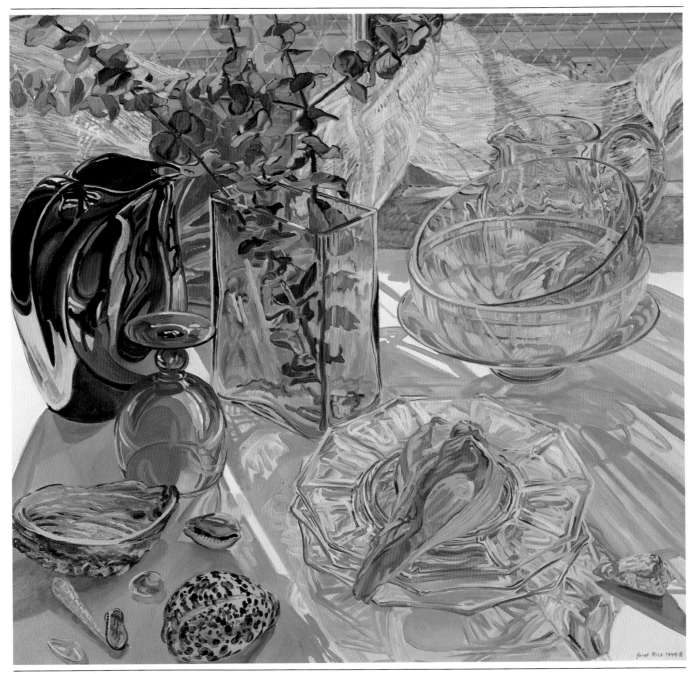

Glass and Shells, 1990
Oil on canvas, 52 x 52 in.
Photo, © Phillips/Schwab
Courtesy, Robert Miller Gallery, New York

Audrey Flack

Photo, ©Ann Chwatsky

"I have always incorporated archetypal images into my work. Using Greek and Roman mythology as references, I began to see in my models ancient Goddesses in contemporary bodies."

When discussing photorealism or super realism of the 1960s and 1970s it is impossible to ignore the work of Audrey Flack. However, for the past decade it has been in the field of sculpture that Flack has devoted her energies. Still, her sculptures retain the symbolism and icons that made her paintings so distinct.

In the early 1980s she began what grew into an unplanned series of sculpted goddess figures. The project evolved naturally from several forces, including the models who posed for the work, changing social attitudes, Flack's interest in 19th century sculpture, and from her personal readings and re-interpretations of classical myths about female deities. These sculpted goddess figures in the self-control and strength they depict, defy and question the prevailing stereotypes about the maleness and the femaleness.

Flack's art, whatever form it takes, always transforms her subjects into symbols of sphinx-like wisdom, which transcend time and space.

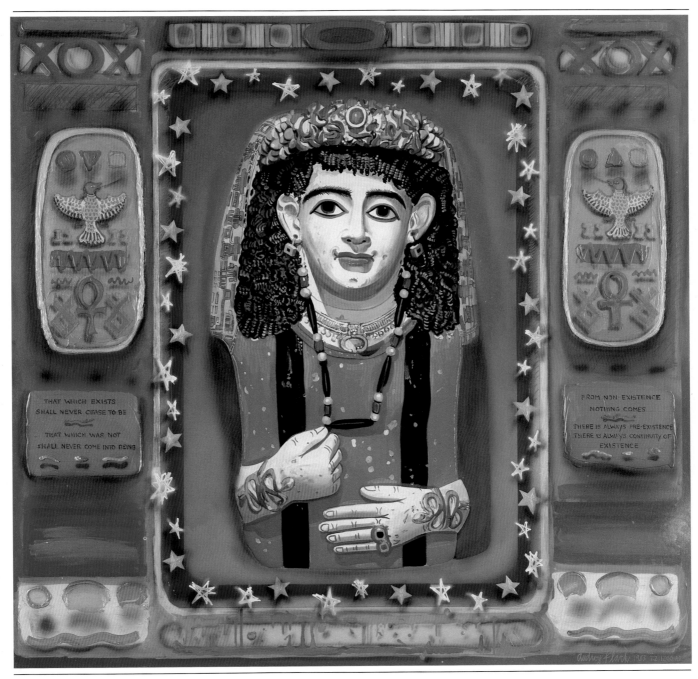

Isis, 1983
Acrylic on canvas, 60 x 60 in.
Photo, ©Steve Lopez
Courtesy, Louis K. Meisel Gallery, New York

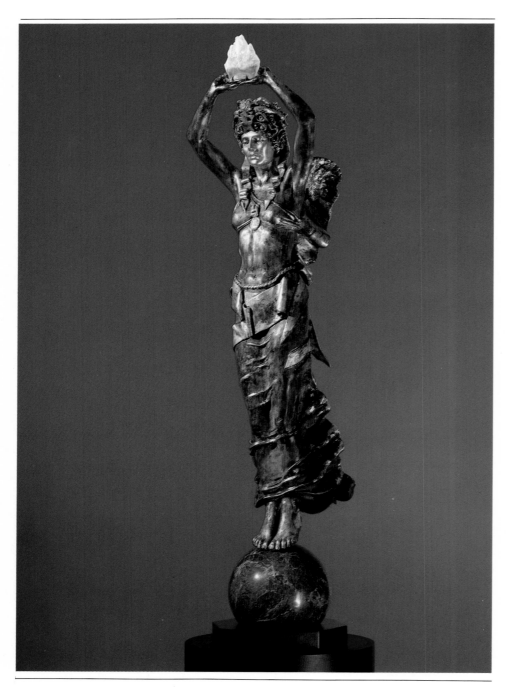

Maquette For "Civitas", 1988
Patinaed and gilded bronze, 57 x 12 x 17 in.
Photo, ©Steve Lopez
Courtesy, Louis K. Meisel Gallery, New York

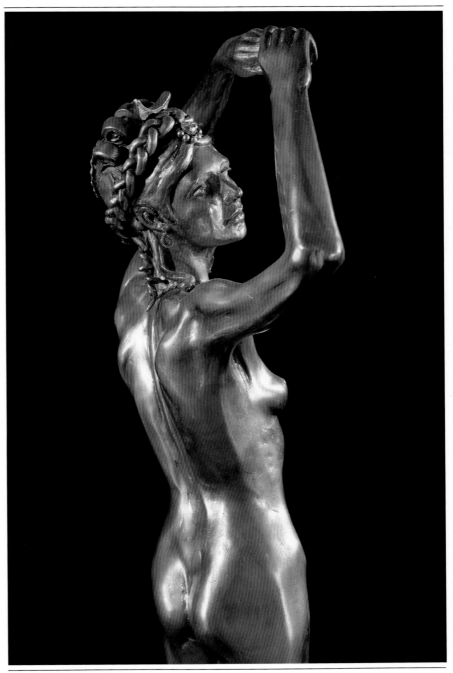

Diana, (Detail), 1988
Gold-plated bronze with jewels, 30 in. high with base
Photo, ©Steve Lopez
Courtesy, Louis K. Meisel Gallery, New York

Jane Freilicher

Photo, ©Joe Hazan

"**People often dig so deeply to find the mystery of a painting, and yet it's almost a biological thing—like your posture, or how you sign your name. You just can't do it another way.**"

"In the beginning, I had very humble aspirations. I just wanted to see if I could paint. I really didn't know how it was going to turn out or whether I would actually achieve anything. But I kept on doing it, and little by little it all accumulated into a life of painting.

"I'm not really interested in symbolism per se. But obviously, on some level, everything is a symbol or metaphor. Landscape painting itself is probably a metaphor for some kind of physical sensation in your body—I mean, I often think it has to do with the recumbent figure. And maybe presenting it through the studio window even has some Freudian significance in that the pleasure of painting, the desire to paint, has something to do with the permission to be a voyeur. It legitimizes your need to peer endlessly at the world, to wonder what might be happening in those houses across the bay. But in another sense, it's really not all that profound."

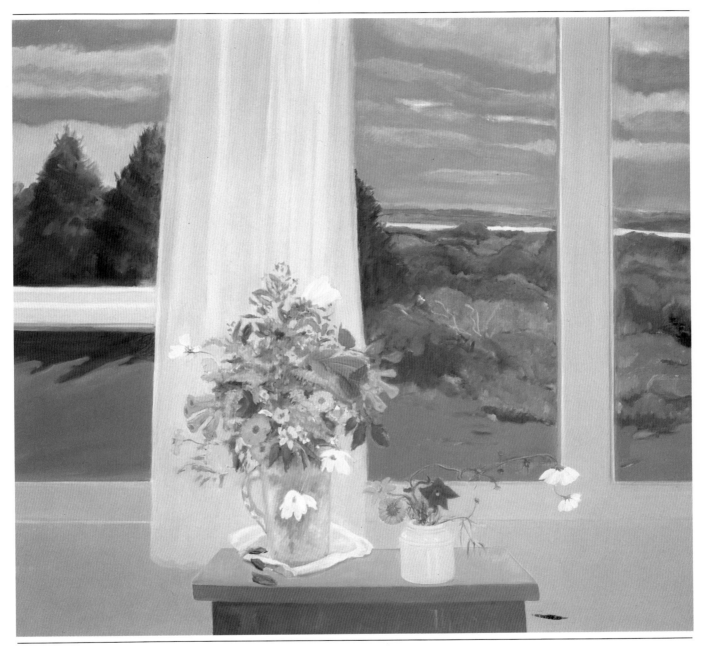

The Sun Breaks Through, 1991
Oil on linen, 47 x 49½ in.
Courtesy, Fischbach Gallery, New York

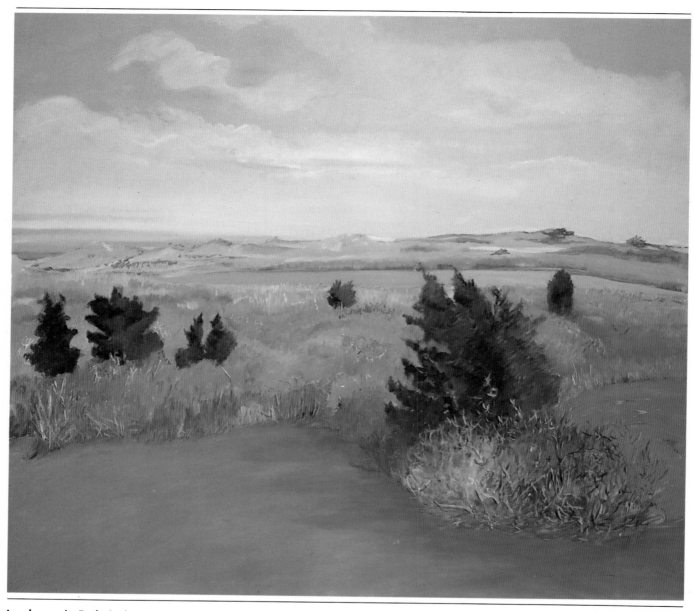

Landscape in Early Spring, 1989
Oil on linen, 36 x 40 in.
Private Collection
Courtesy, Fischbach Gallery, New York

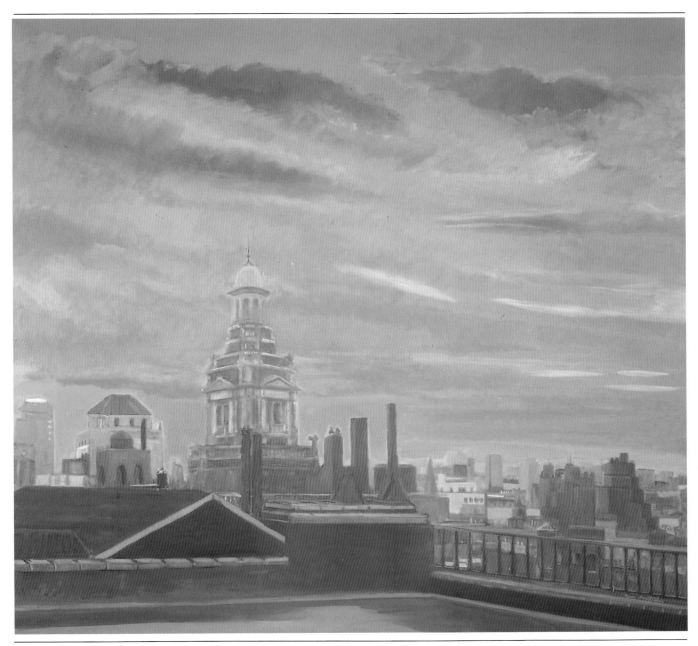

From a Window Near the Sky, 1990
Oil on linen, 47 x 50 in.
Courtesy, Fischbach Gallery, New York

Viola Frey

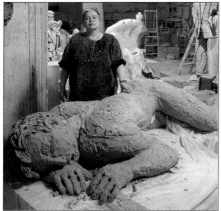

Photo, ©Lee Fatherree, 1987

My images "... carry with them contradictions which challenge our own sense of self and which also challenge the inanimate immobility we initially attribute to *object* and *thing*."

Viola Frey's paintings and especially her polychrome ceramic sculpture offer a startling view of emotional turmoil submerged in the sameness of everyday life. Massive in size, the heavily pitted, rough and unnaturally colored sculpted figures seem intensely awkward with themselves. Her paintings also speak of alienation and emotional and psychological turmoil.

Frey's people display a stiff, cramped demeanor. They are clearly out of place in a world that has no connectedness or relevance. Some seem filled with anger and frustrated aggression. Others are in postures of tentativeness and indecision; even their clothing seems to act as an inhibitor causing them to maintain a cramped posture while their faces speak of a desire to break free. All of Frey's subjects are caught up in the whirlwind of their own emotions, too busy to interact with each other.

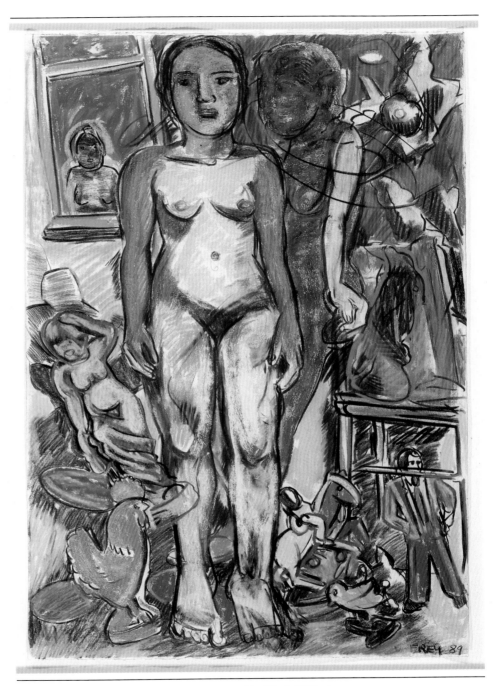

Untitled, 1989
Pastel on paper, 41 x 29 in.
Private Collection
Courtesy, Rena Bransten Gallery, San Francisco

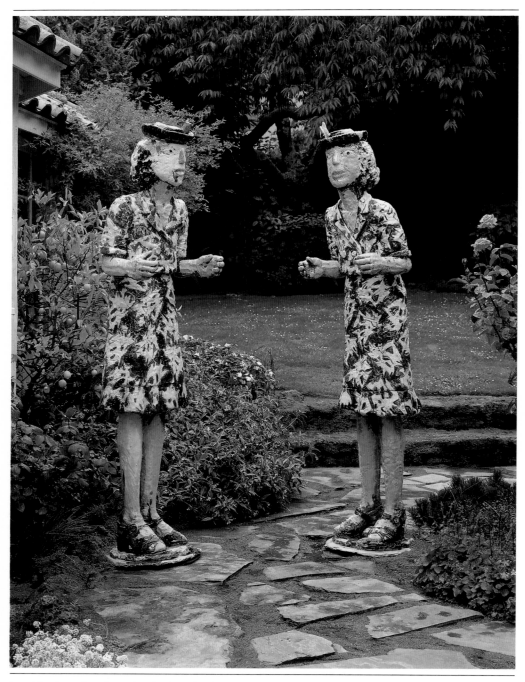

Double Grandmothers in Black and White Dresses, 1982
Ceramic, 86 x 20 x 20 in. (each)
Courtesy, Rena Bransten Gallery, San Francisco

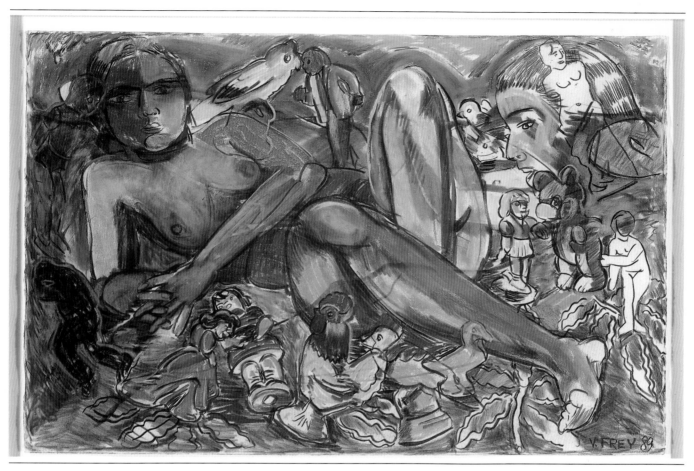

Untitled, 1989
Pastel on Paper, 30 x 44 in.
Private Collection
Courtesy, Rena Bransten Gallery, San Francisco

Yvonne Jaquette

"...sometimes it looks as if I'm doing realism going toward abstract, and abstract going toward realism."

Yvonne Jaquette is one of the foremost painters associated with the emergence of American New Realism during the late Sixties. Realism at that time was risky; those who went against the grain of abstract and pop art were often looked upon with distain. Now, says Jaquette, the definitions of realism and abstract have been blurred.

Jaquette makes pastel sketches or takes photos from airplanes or tall buildings, to help her when she is doing her final painting in the studio. In her work, she tries to capture the tension, irony and even history of the battle between what mankind creates and what nature intends.

Beauty full of the possibility of catastrophe is a theme of many Jaquette paintings. Her flying forays have taken her over numerous nuclear power plants. Her painting of Three Mile Island was held to black and white, "To get a much more horrific quality of those towers at night."

For each locality she paints, Jaquette weaves together a unique combination of man-made and natural elements into a tapestry-like whole.

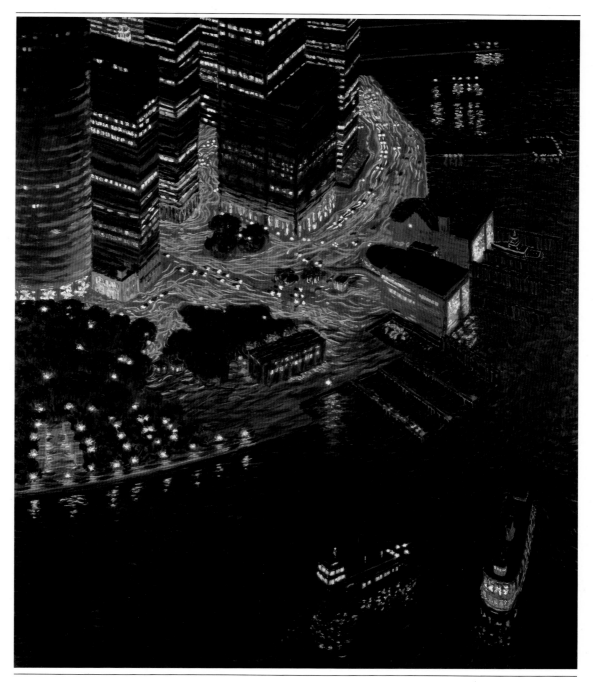

Manhattan Nocturne: Late Evening Traffic, 1988
Oil on canvas, 84 x 70 in.
Private Collection
Courtesy, Brooke Alexander, New York

Tokyo Street with Pachinko Parlor II, 1985
Oil on canvas, 85 x 55 in.
Private Collection
Courtesy, Brooke Alexander, New York

Town of Skowhegan, Maine V, 1988
Oil on canvas, 78 x 64 in.
Courtesy, Brooke Alexander, New York

Marisol

Photo, ©Jack Mitchell, New York

"Whatever the artist makes is always some kind of self-portrait."

Marisol sculptures seem like a canvas for portraits which she paints on them. This is not surprising since she started her art career as a painter.

Since the early 1960s the portrait has been one of Marisol's primary ways of expression. No one "sits" for these boxy sculptures of fellow artists like Andy Warhol and Georgia O'Keeffe or political figures like Archbishop Desmond Tutu of South Africa and Emperor Hirohito of Japan. Rather, Marisol relies on photographs and her memories to construct her portraits. Her works are made from large cubes and rectangular pieces of found wood on which faces and figures are then drawn, painted or carved.

The uniqueness of Marisol's art lies in the way it broadens the traditional boundary of sculpture while also providing a wry running commentary on the state of society and self.

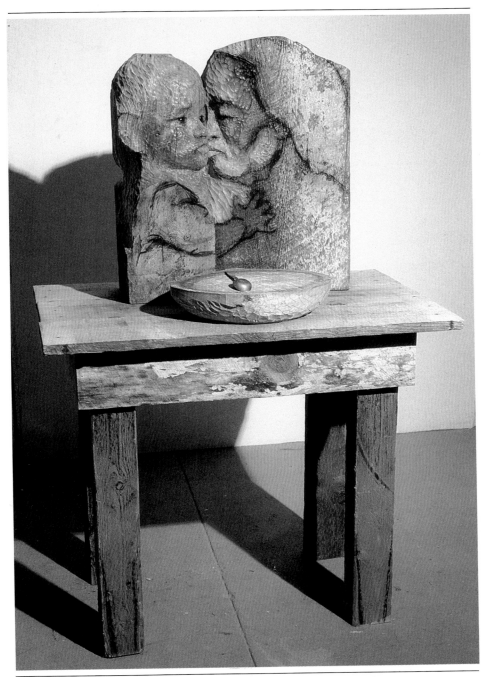

Mother and Child with Empty Bowl, 1984
Wood and charcoal, 56 x 63 x 36 in.
Private Collection
Courtesy, Sidney Janis Gallery, New York

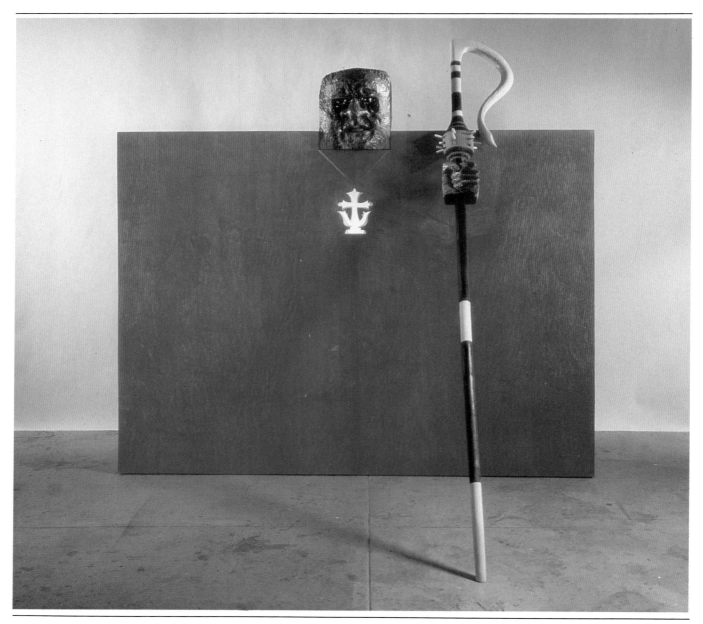

Portrait of Bishop Desmond Tutu, 1988
Wood, stain, fluorescent light, 75 x 79-1/2 x 51 in.
Courtesy, Sidney Janis Gallery, New York

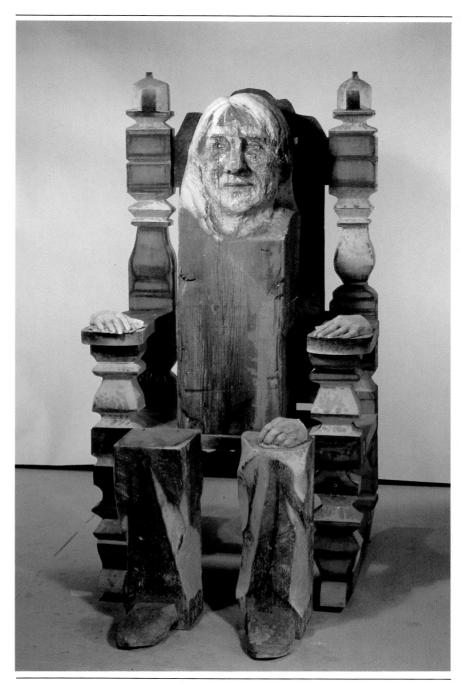

Portrait of De Kooning, 1980
Charcoal and oil on wood and plaster, 60 x 32 x 46-1/2 in.
Private Collection
Courtesy, Sidney Janis Gallery, New York

Joan Mitchell

Photo, Robert Mapplethorpe, 1982

"Empathy . . . that's all my painting is about. My empathy with nature, dogs, gardens. It has to do with something you feel."

Joan Mitchell, an American painter living in France, has been an abstract expressionist for over 40 years. Her form is the landscape and she, like a musician, establishes a theme and improvises around it. Mitchell has remarked: "I used the landscape as an expression of things, but also for enormous protection against people . . . painting has allowed me to survive."

She has found great inspiration from her friendship with poets and many of her works relate directly to the feelings that were engendered by certain poems. She has been able to use what she refers to as the "controlled accident" to synthesize and renew a "consistent visual language." Mitchell's works reflect her deep-rooted passion for the beauty of nature and an awareness of the brevity of life. The brushwork displayed in her paintings is extremely varied: thin and wide, rolling and lashed, sensitive and aggressive. The energy they convey is restless.

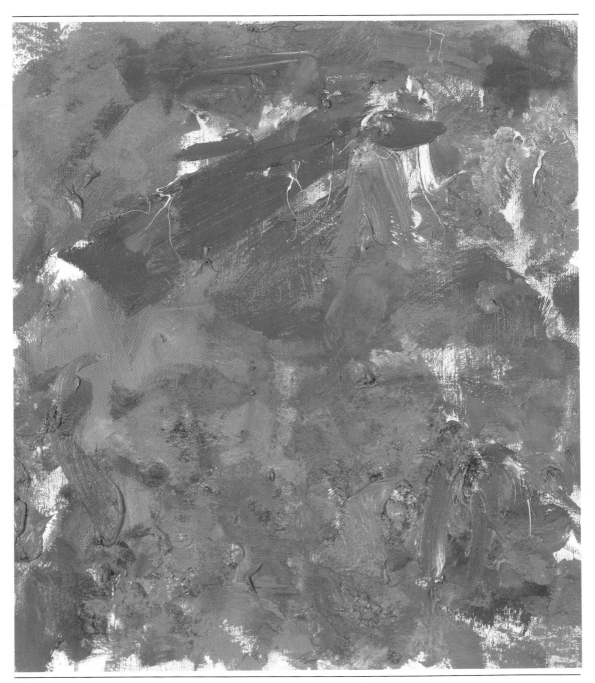

Gently, 1982
Oil on canvas, 21-1/2 x 18 in.
Photo, © Zindman/Freemont
Courtesy, Robert Miller Gallery, New York

Joan Mitchell

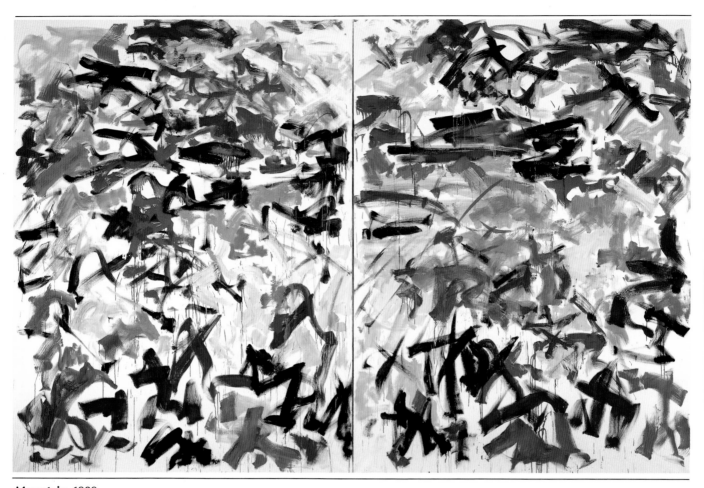

Mountain, 1989
Oil on canvas, 110-1/4 x 157-1/2 in.
Photo, © Phillips/Schwab
Courtesy, Robert Miller Gallery, New York

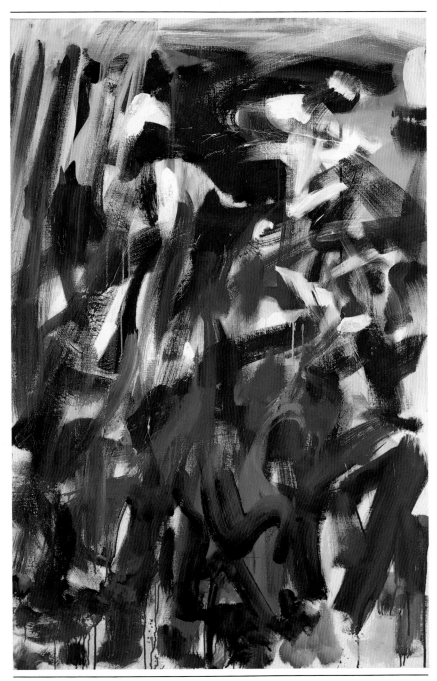

Weather, 1989
Oil on canvas, 51-1/4 x 32 in.
Photo, © Phillips/Schwab
Courtesy, Robert Miller Gallery, New York

Elizabeth Murray

Photo, ©Susan Cataldo, 1990

"I think I'm trying to devise a new way of painting The thrill is always being able to reinvent your structure—to never accept your old structure."

"I have an enormous love and respect for traditional painting. But I think that in a structural kind of way it isn't enough for me. I have a fascination with relief—with the possibilities of two dimensions going into three—a fascination with illusion. My ideas, I think, come from watching movies. The paintings are like 3-D turned into the flat and mixed with a sense of mystery and strangeness.

"When I first started to make these irregular shapes, I didn't have any idea what I was doing. I wasn't aware of what it meant to put a shape on the wall. Then I discovered it made the wall very different. In 1980, I put two shapes together and called it *Breaking*. I realized what I was after—a space where the wall could be seen through the picture. All my work is involved with conflict—trying to make something a disparate whole. When I put these shapes together, the wall itself becomes part of the conflict.

"A lot of what I do is a struggle between high and low. Highbrow and wanting to be Leonardo on the one hand, and on the other, my childhood and wanting to do comic books. And in between, I had a classical training, so I know how to paint a figure.

"Reinventing structure each time is also, I suppose, like coming to terms with your body. The physical and sensual are always escaping definition, and that's what I've been interested in. In the middle of a painting, there is a moment when you get beyond yourself a little. The meaning comes before and after, like making love.

"I want to make a *possibility* with a painting. A painting is a still thing on a wall. I want this openness and indeterminacy, and yet the picture is very determined—once it's there you can't change it. My work is mute in a certain way. I think that's the beautiful thing about it—that it's so vulnerable. Something is exploded out of its ordinary context into a new state."

Quotes excerpted from an article, "One From the Heart," by Kay Larson, New York, February 10, 1986.

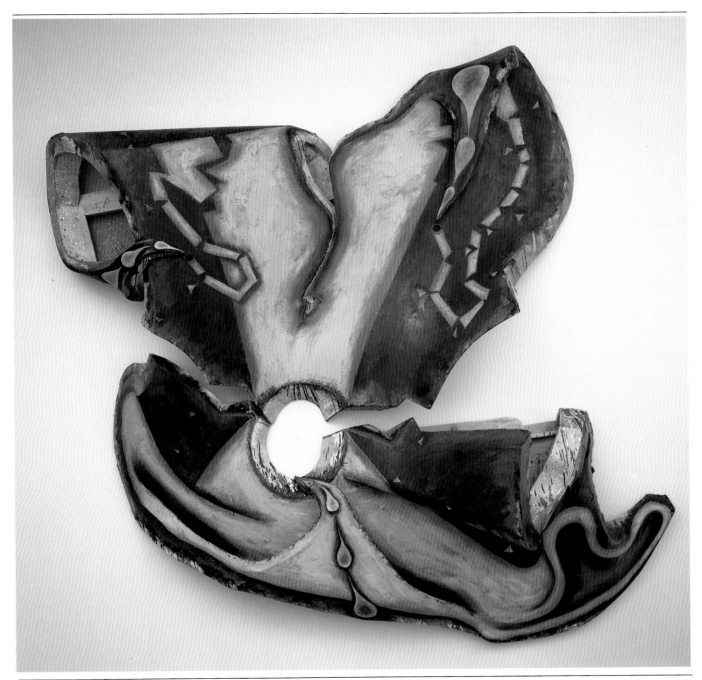

Things to Come, 1988
Oil on canvas, 115 x 113 x 27 in.
Photo, ©D. James Dee
Private Collection, San Francisco
Courtesy, Paula Cooper Gallery, New York

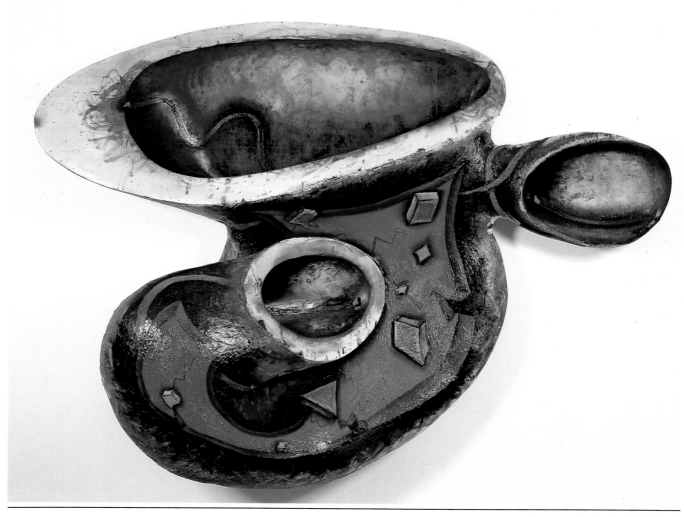

Stay Awake, 1989
Oil on canvas, 68⅞ x 89⅞ x 25 in.
Photo, © Geoffrey Clements
Collection, Mr. and Mrs. Marvin Gerstin, Chevy Chase, MD
Courtesy, Paula Cooper Gallery, New York

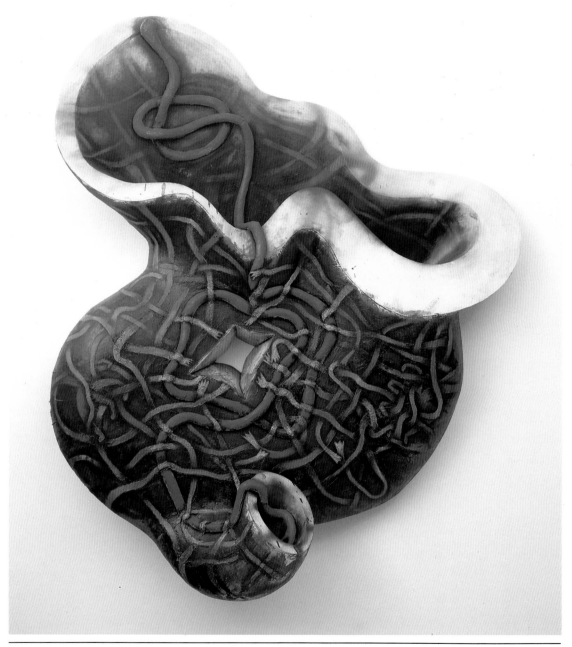

Tangled, 1989-90
Oil on canvas, 83½ x 66 x 19 in.
Photo, ©D. James Dee
Collection, Gallery Mukai, Tokyo
Courtesy, Paula Cooper Gallery, New York

Adrian Piper

Self-portrait, 1981

"My work tends to target interpersonal manifestations of racism rather than institutional ones."

Adrian Piper works in a variety of media: installation; documentation with maps, photographs, charts and descriptive language; performance; photo-text collage; drawing; video; artist's books; etc. Since the late 1960s her work is unified not by medium but by concept. She identifies herself as a conceptual artist.

Piper's purpose in her work is political. She strives to contribute to the creation of a society in which racism and racial stereotyping no longer exist. As a woman of color, she wants the viewers to come away from her work with the understanding that their reactions to racism are ultimately political choices over which they have control—whether or not they like her work or credit it for this understanding. She states, "I am interested in truth rather than beauty."

Depending on the composition of Piper's audience, her work functions differently. As she puts it, "For a white audience, it often has a didactic function: It communicates information and experiences that are new, or that challenge preconceptions about oneself and one's relation to blacks. For a black audience, it often has an affirmative or cathartic function: It expresses shared emotions—of pride, rage, impatience, defiance, hope—that remind us of the values and experiences we share in common."

UR Mutter #8, 1989
Photo-text collage with silkscreen text, 36 x 59-1/2 in.
Courtesy, John Weber Gallery, New York

...of Harlem called Sugar Hill, where there were lots of parks and big houses th
at had once been mansions but had been converted into hotels or funeral
homes. When I was little it was nice. ... didn't start loitering in the ha
llway of my building ... four-part ... money until I was around eight. Aft
er that it got seedy very quickly. Around the same time many of the girls in
school started wearing shoes from ... and coats from Bonwit Teller's.
Suddenly I began to notice that they all had maids and doormen and lived in a
partments bigger than my whole building. I hadn't noticed it before because
it hadn't determined who was popular before. Before it had been how smart an
d nice and good at sports you were. Nobody had ... about where they bough
t their clothes or how many servants they had. It was difficult, but becaus
e I was an only child, my parents could keep up ... a lot of this. My mothe
r had a very good, steady job as a secretary ... City College, and my father h
ad a very unsteady real estate law practice in Harlem, where people paid him
for defending them against unscrupulous landlords by mending his shirts or co
oking things for him or fixing his car. My parents spent all their money on
me. They put me through twelve years of New Lincoln (a fancy private prep sc
hool). They gave me ballet and modern dance lessons at Columbia University.
I took piano lessons first from a neighbor, and later from a teacher at Juil
liard. I got art lessons from the Museum of Modern Art and the Art Students'
League. Once I even got a coat from Bonwit Teller's. Although my mother nor
mally took me on shopping trips only to places like Macy's or Gimbel's, I dre
ssed as well as anyone else in the class and was invited to all the parties a
nd had cute white boyfriends. But I became ashamed to invite people over or
have my boyfriends pick me up because I lived so far away and the neighborhood
and everyone in it seemed so alien and sinister next to my rich white New Lin
coln friends. I could have stood not having had any servants if we at least
had had a big apartment in a large building with an awning and a doorman. At
least an awning. The final blow came when I was eleven. I had been too emba
rrassed by my house and neighborhood to give a party although all the other p
opular kids in my class had. So I had started noticing all the advertised va
cant apartments on Fifth Avenue, Park Avenue, and Central Park West as I came
home from visiting my friends who lived there. And one day said to my moth
er, why don't we move? I just saw a sign for a lovely twelve-room apartment
at Fifth Avenue and Eighty-Sixth Street, and it's so small and dark and crowd
ed here. My mother laughed a very angry and bitter laugh and said, Get that
idea out of your head right now. We don't move to Fifth Avenue because we do
n't and never will have that kind of money. I was shocked and didn't believe
her at first. I thought she was just in a bad mood the way she always was wh
en I asked her for new clothes, and that she was that way because she just di
dn't want me to have them. But when I brought it up again, carefully, a few
days later, she saw that I really didn't understand. So she explained very p
atiently and carefully that we lived where we did because we had to, not beca
use we wanted to. She explained about Daddy's deciding to serve his community
and getting paid in apple pies and embroidered shirts when he got paid at all
, and about how many weeks of a secretary's salary a coat from Bonwit Teller'
s cost. I was stunned. I became very depressed. Reality began to look very
different after that. I started becoming more and more estranged from my sch
ool friends. I saw that I would never be able to keep up with them economica
lly and was almost relieved to drop out of the race. I realized that all alo
ng, they had inhabited a world which I had never in fact had access to. It d
isgusted me to think that I had tried so hard to emulate them. I began dress
ing arty rather than junior miss, and to spend time at home listening to clas
sical music and reading novels rather than going to school parties. I found
that I didn't miss those parties at all. I spent a lot of my free time in li
braries and museums. I became reflective and started to keep a journal. Tha
t was when I began to understand the choices and sacrifices my parents had ma
de in order to educate me; and the inner resources they had insisted that I d
evelop. Those resources became a refuge for me now. I learned to be self-su
fficient, and to revel in my solitude. But by that time my self-image had be
en too strongly affected and formed by my school associations, as much as by
the complexities of my total environment. I still have tastes I can't afford
to satisfy except by getting into debt, which I do, and then feel simultaneou
sly guilty and frustrated for having them. My standard of living seems to me
excessive for an artist and an academic, even though I know I would find anyt
hing less barren and depressing. I dream unrealistically of the political an
d economic purity of the ascetic's life, and of the revolution which will red
istribute the wealth my classmates so undeservedly enjoyed. I fear having mo
re money because I know my taste for books, records, art, clothes, and travel
will increase, leaving me with none of the extra cash I now give to support t
hat revolution. I watch with detached anxiety as I sink further into the mor
... material desires at the same time as I ascend the ladder

Political Self-Portrait #3 (Class), 1980
Photostat, size unknown
Courtesy, John Weber Gallery, New York

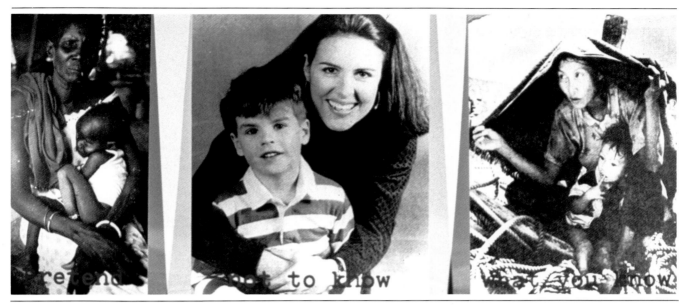

Pretend #2, 1990
Three enlarged newspaper photos, silkscreened text 43-7/8 x 96 in.
Courtesy, John Weber Gallery, New York

Faith Ringgold

Photo, © C. Love

"In making quilts I am able to communicate ideas I would not be able to communicate in any other way. They are a platform for mixing art and ideas so that neither suffers."

Faith Ringgold, painter, sculptor, performance artist and author was born at Harlem Hospital, New York City, in 1930. Ringgold has been an articulate and highly visible spokesperson for the rights of both people of color and women artists.

In 1983 she created her first "story quilt" entitled *Who's Afraid of Aunt Jemima?* This unique form of painting combines unstretched canvas that is painted with acrylic paints, pieced fabric borders and Ringgold's original stories written directly on the "quilt." In her work, Ringgold identifies her place in the world, acknowledges the need for cultural change and, in some of the "quilts," voices the hope that this change will take place. The "story quilts" satisfy Ringgold's basic need to address political and social issues in contemporary life. They bridge the gap between image and language and between the personal and political.

The "story quilts" are nurtured by a culture with a strong oral tradition and by a family of great storytellers. Ringgold speaks eloquently of the roles of gender, age, family loyalty, generational relationships, obsession, hatred and love in American life — past and present.

The "story quilts" are a manifestation of her political concerns as a Black Woman in America. In them, Ringgold re-affirms the Black Women's capacity to speak and to voice a specifically feminine Black perspective in a white, male-dominated society.

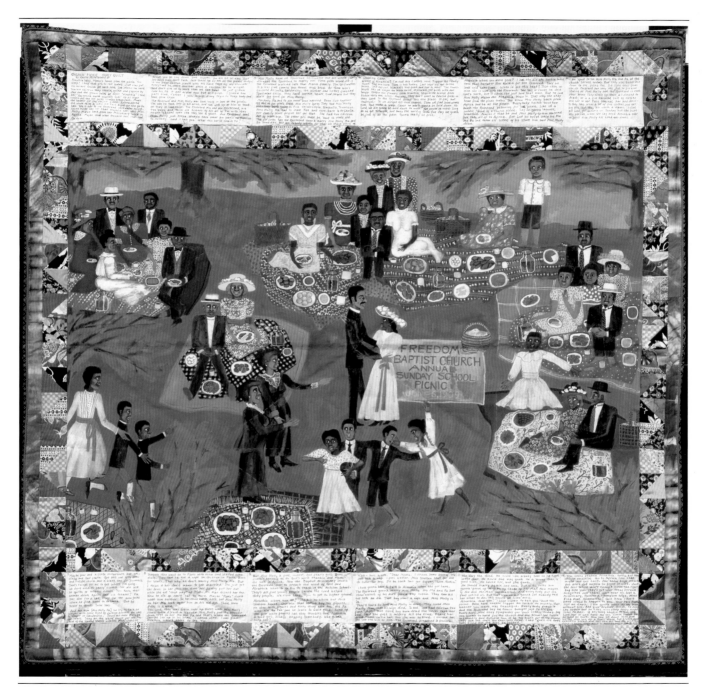

Church Picnic Painted Quilt, 1988
Painted canvas, pieced, dyed, printed fabrics, 74½ x 75½ in.
Collection, High Museum at Georgia-Pacific Center, Atlanta, GA
Photo, © Gamma I
Courtesy, Bernice Steinbaum Gallery, New York

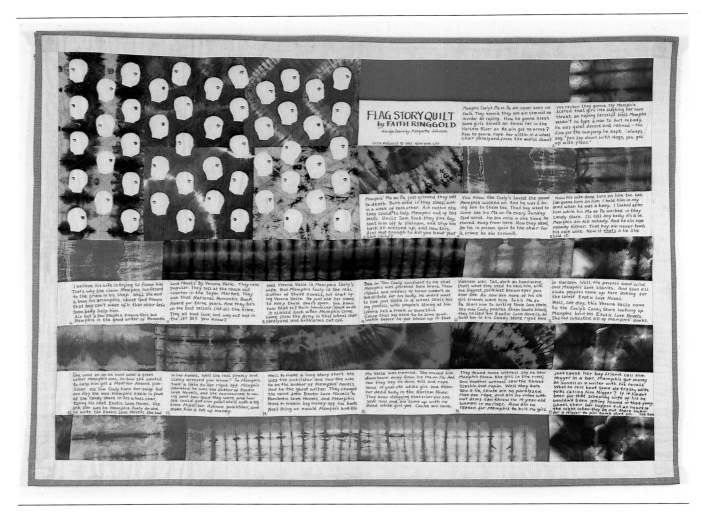

Flag Story Quilt, 1985
Dyed and pieced fabric, 57 x 78 in.
Collection, The Spencer Museum of Art, University of
Kansas, Lawrence, KS
Courtesy, Bernice Steinbaum Gallery, New York

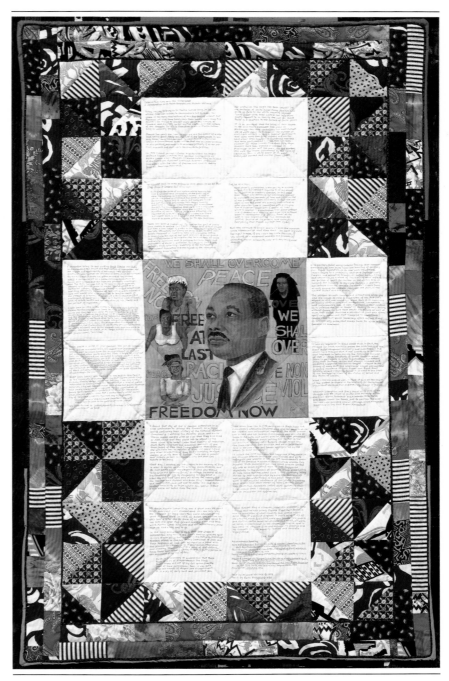

Dream Two: King & the Sisterhood, 1988
In collaboration with Michele Wallace
Painted canvas, pieced, dyed, printed fabrics 94 x 60 in.
Photo, © Gamma I
Courtesy, Bernice Steinbaum Gallery, New York

Dorothea Rockburne

Photo, ©Duane Michals

"My thinking deals with the involvement of experience. Then experience accumulates to become phases of information. While it is being ingested it takes on a new form which then goes into the work."

Each of Dorothea Rockburne's works deals with some concept of interrelatedness and function. Set Theory in mathematics, because of its objective consistency, has guided Rockburne's work. Mathematics, unlike literature, employs straight and clear thinking. While there is a parallel for Rockburne between her art and Set Theory, her work is not meant to have a one-to-one correlation with it.

Rockburne's art materials are cardboard, paper, oil, and nails. She employs a series of operations using them which include soaking, rolling, unrolling, pressing, hanging and layering. She has stated, "I don't like material as such, whether it's oil paint or anything else, because it leads you into a trap. The trap is that materials, in themselves, present a certain truth which one has to work with. I don't want to work with the truth in materials, except in a very limited wayI'm interested in the ways in which I can experience myself, and my work is really about making myself."

Rockburne combines her ideas and materials with a certain amount of uneasiness due to the initial separation between the idea, the materials being used and herself. Within her there is a need to understand all aspects involved in order to bring them together in a convincing whole. She puts the work up and takes it down several times before completion. Rockburne says that it is as though she and the work change places. "I no longer contain the information, the work does."

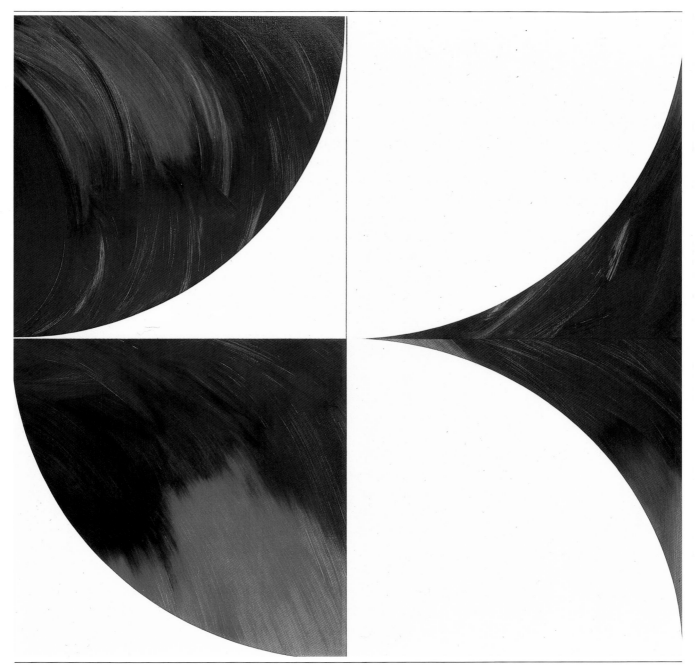

Still Blue Circle, 1990
Oil on linen, 66 x 66 in.
Courtesy, André Emmerich Gallery, New York

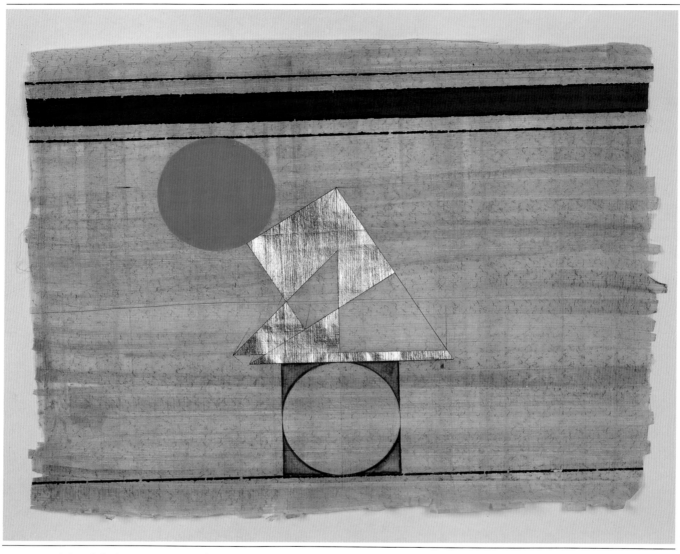

Memory of the Light in Egypt, 1989
Gold leaf, india ink, gouache and watercolor on papyrus and
museum board, 25½ x 29⅜ in.
Courtesy, André Emmerich Gallery, New York

Pascal's Provincial Letters (Three panels), 1987
Oil on linen, 67 x 67 x 8 in.
Courtesy, André Emmerich Gallery, New York

Miriam Schapiro

Photo, ©Suzanne Opton, 1990

"In my paintings that deal with Frida Kahlo, I pay homage to a woman who decided to be a painter."

"Femmage is the term that Miriam Schapiro coined as a variant on the technique "collage." "Femmage" implied the kind of activities that women had practiced for centuries when they used traditional craft techniques like sewing, piecing, hooking, quilting and appliquéing. The extensive use of fabric patchwork quilt blocks, embroidery and crochet are iconographically part of Schapiro's conscious effort to re-establish connections with an older authentic tradition.

Schapiro re-invented a lexicon of forms including houses, hearts, screens and fans which were inspired by the domestic forms found in quilts.

In 1986, at the age of 64, Schapiro created a 35 foot high, 22,000 pound outdoor sculpture entitled *Anna and David*. These figures with their dance movement, body gesture and intense color were the first of her cut-out dancers to be translated into sculpture. In Schapiro's playful, poetic, and pragmatic art of life and illusion, the dancing figures could in many ways be considered her self-portraits.

Schapiro, like her work, refuses to be "boxed-in" or "pigeon-holed" with any one particular movement in art history.

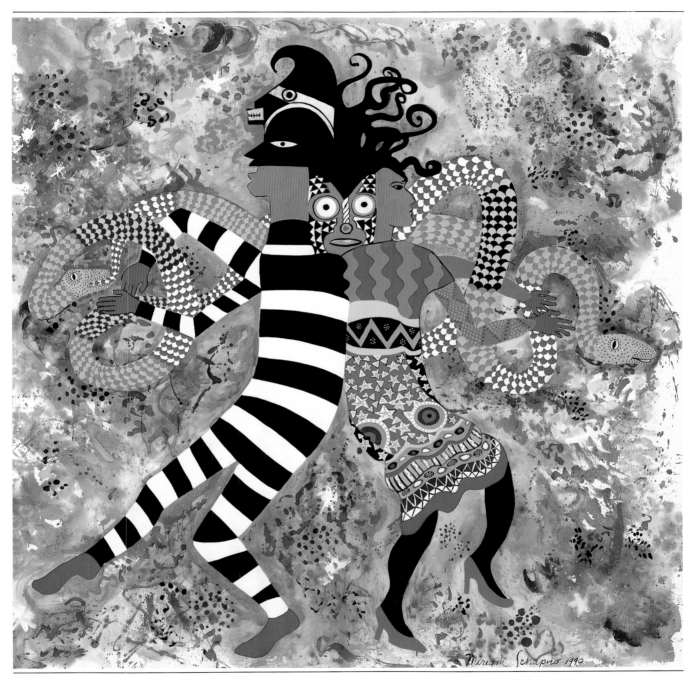

The Garden of Eden, 1990
Acrylic on canvas, 95½ x 95½ in.
Courtesy, Bernice Steinbaum Gallery, New York

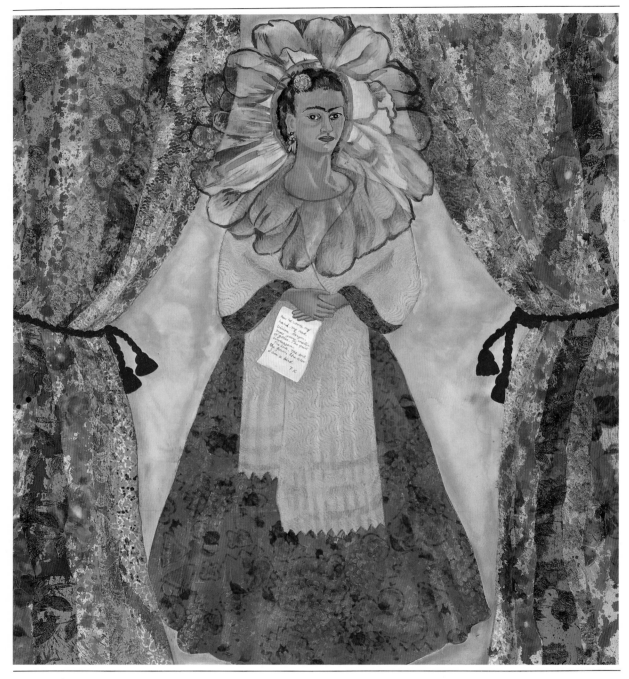

Presentation, 1990
Acrylic and fabric on canvas, 80 x 72 in.
Collection, Dr. and Mrs. Harold Steinbaum
Courtesy, Bernice Steinbaum Gallery, New York

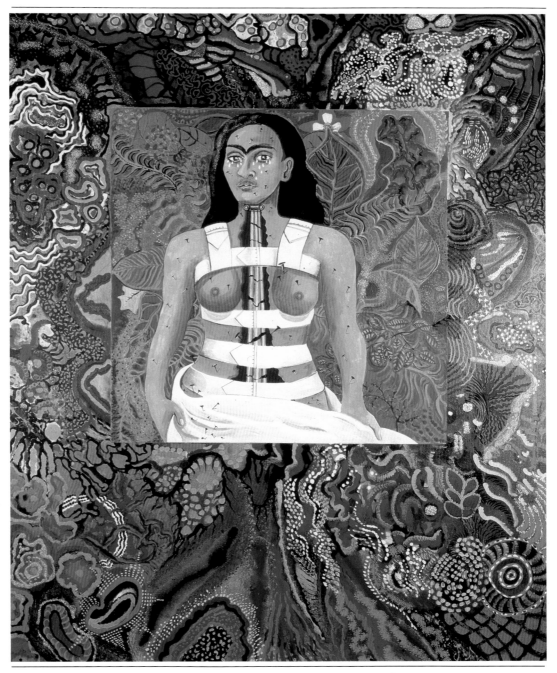

Agony in the Garden, 1991
Acrylic on canvas, 90 x 72 in.
Collection, Brooklyn Museum, Brooklyn, NY
Courtesy, Bernice Steinbaum Gallery, New York

Cindy Sherman

Cindy Sherman's photographic fabrications, which almost always star herself, have been inspired by film, fashion, girlie magazines, children's fairy tales, old-master paintings and recently, scenes from grade-B horror or disaster movies. When she is before the camera, she uses props, makeup, false noses, camera angles and lighting, to create a nearly infinite number of emotions and moods in her images. Sherman becomes transparent: a "still" model or actress who has disappeared into her role.

Sherman's photos are a deconstruction of the feminine mystique. Her early pictures have a desolate mood, one of being stranded and waiting but not knowing for what. They give way to pictures of lonely, romantic longings. Later images move into the unpleasant extremes of emotion. The prevailing mood of these pictures is one of restrained depression. Currently, Sherman is exploring the chaos of mental disintegration. She allows the dark side and its attendant images which have been previously repressed to surface. Sherman seems to be saying through her collective work that repression and denial of unpleasantness in favor of the American dream will fill the unconscious with a repressed energy that will erupt in destructive violence.

Untitled, 1985
Color photograph, 67¼ x 49½ in.
Courtesy, Metro Pictures, New York

Cindy Sherman

Untitled, 1982
Color photograph, 45 x 30 in.
Courtesy, Metro Pictures, New York

Untitled, 1989
Color photograph, framed, 46 x 40 in.
Courtesy, Metro Pictures, New York

Alexis Smith

Photo, © Catanzaro/Mahdessian

"I get a huge kick out of what I do. I like doing it. I like it when it's finished, and that's carried me through the years."

Alexis Smith's collages, made of found artifacts, show her skill, creativity and knack for having fun with her work. Some of her success is due to her self-confident attitude: "I went through a catharsis when I was about 35, and I decided that it's just as well to assume you are good because you will never know during your lifetime. It takes such a load off to assume you are good and just put one foot forward."

Smith has been putting one foot in front of the other with grace, wit and daring since graduating from the University of California at Irvine in 1970. She quickly gained acclaim for her detailed narrative collages. Her pieces are examinations of popular culture usually revolving around a belief about, a quote from, or a myth of contemporary society. She does not seek to judge society but wants to help people zero in on a complex truth that involves reconciling opposites.

Smith's work also includes large public pieces such as the 10-foot-wide, 500-foot-long snake-shaped path on the University of California at San Diego campus. Looping around a miniature "Garden of Eden," the snake path connects the library to the engineering building.

When asked about her growing success, she has said, "You stay the same and everyone else changes."

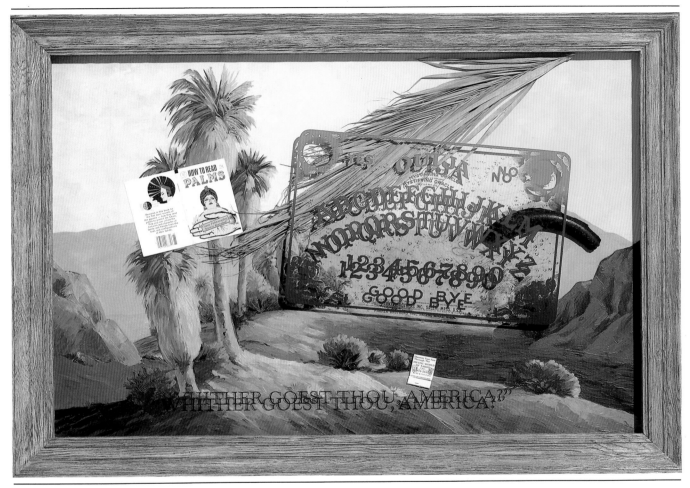

Palm Reader, 1989
Mixed media collage, 43 x 30-3/4 in.
Collection of James and Linda Burrows
Courtesy, Margo Leavin Gallery, Los Angeles

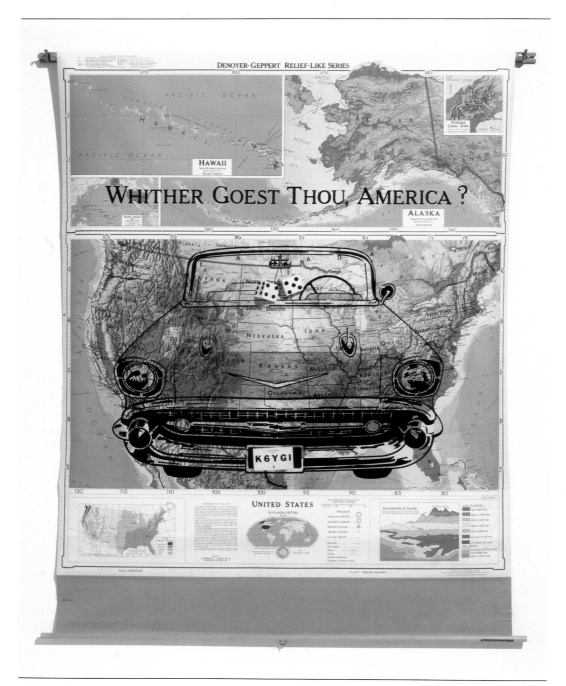

Pair O'Dice, 1990
Mixed media collage, 85-1/2 x 67 x 3 in.
Collection of James and Linda Burrows
Courtesy, Margo Leavin Gallery, Los Angeles

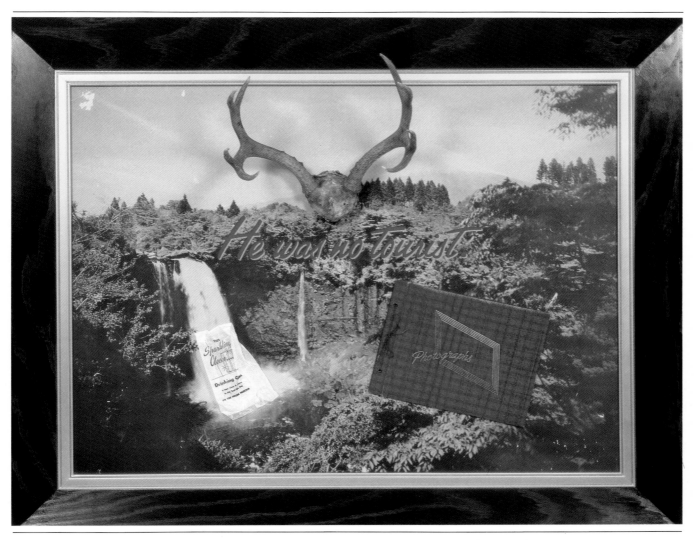

Native American, 1990
Mixed media collage, 45-1/4 x 58-1/4 x 14 in.
Collection of James and Linda Burrows
Courtesy, Margo Leavin Gallery, Los Angeles

Jaune Quick-to-See Smith

"As far back as I can remember, I wanted to be an artist before I knew the word."

Jaune Quick-to-See Smith, a Native American of Flathead, Cree and Shoshone tribal heritage, was born and raised on the Flathead Reservation in Montana. Living now in New Mexico, she still maintains close ties to the people and landscape of the Flathead Reservation. In her work, the artist portrays a reverent view of the land. Smith draws deeply from her own life experiences, traditional Indian heritage, historical western landscape as well as mainstream modern art to communicate her concern for the vanishing West. The western landscape in literature is often portrayed as an uninhabited wasteland. Smith's landscapes are not wastelands. They are pictographs dotted with the remains of earlier civilizations, filled with tracks of animals and scarred by erosion and weather.

In her new body of work, she quotes from Chief Seattle's visionary speech given in 1854. The environmental concerns that he addressed are as relevant today as they were nearly one hundred and thirty years ago.

The artist deals with the new west — the dumping ground for nuclear waste, oil splotches and coal rifts. Her concerns deal with the air and water quality that is being jeopardized by the timber and mining industries. Her paintings insist that all living things must co-exist and that no single life form controls another. Jaune Quick-to-See Smith's work is her plea to each of us to save the earth.

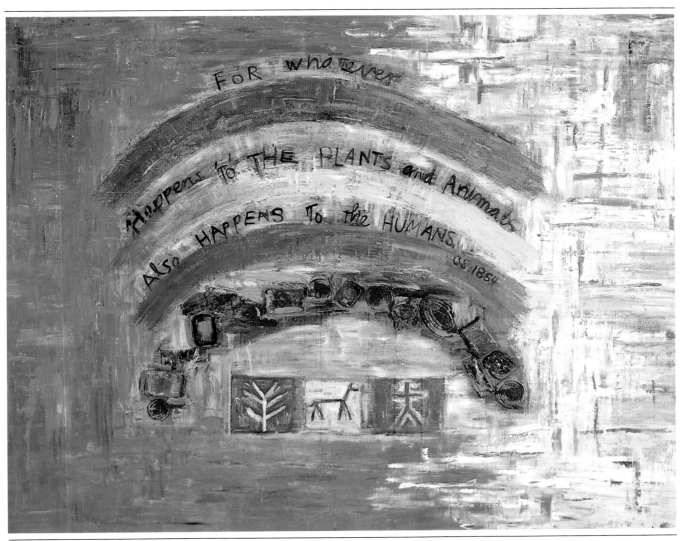

Rainbow, 1989
Oil on canvas, 66 x 84 in.
Courtesy, Bernice Steinbaum Gallery, New York

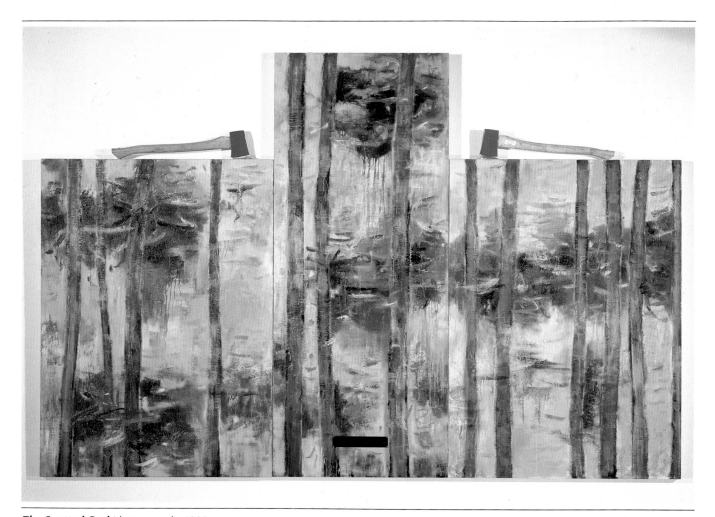

The Spotted Owl (three panel), 1990
Oil, beeswax on panel, 80 x 116 in.
Courtesy, Bernice Steinbaum Gallery, New York

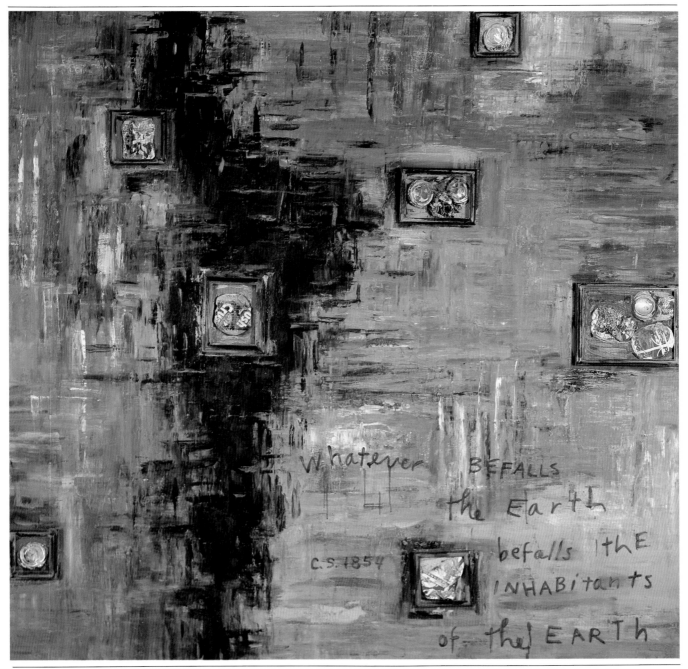

Pictures at an Exhibition, 1989
Oil on canvas, 72 x 72 in.
Courtesy, Bernice Steinbaum Gallery, New York

Pat Steir

Photo, ©Roberta Neiman

"I've been famous twice...first as a 'woman artist' in the 1970s and now as an artist, period."

In the 1970s, Pat Steir probed the historical mainstream to expose the relativity of style. Her paintings made art of art history, taking themes and styles from Rembrandt, Manet, Courbet, Van Gogh, de Kooning and others. The culminating works of this phase were *The Brueghel Series (A Vanitas of Style),* a 64 panel re-creation of a flower painting by Jan Brueghel the Elder, rendered in the style of sixty-four different artists and periods.

Her new paintings are conceived, minimalist-fashion, as a series. The paintings are individual variations on a single image such as in the *Waterfall* series. The paintings are not about the way nature looks; they are about the way life works.

She achieves her rich effects with two oil pigments, white and black and two kinds of strokes. She applies the brush directly to the canvas in short arcs, releasing rivulets of white that stream down the painted black canvas. Alternatively, she flicks her wrist and the paint sprays in a white arc.

Though it looks unbelievably simple, Steir insists that she controls everything, though she admits, it's "chance control." In the *Waterfall* series, the result is a convincing illusion of a waterfall.

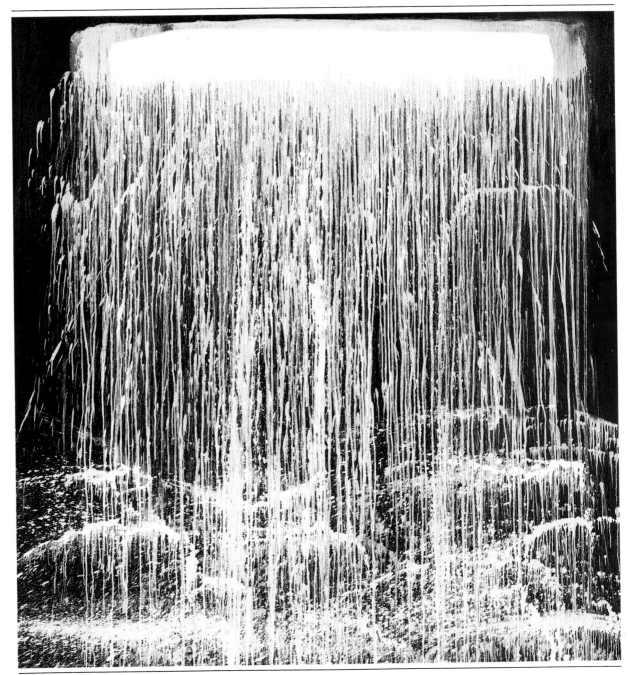

Paris Waterfall, 1990
Oil on canvas, 88 x 98 in.
Photo, © Phillips/Schwab
Courtesy, Robert Miller Gallery, New York

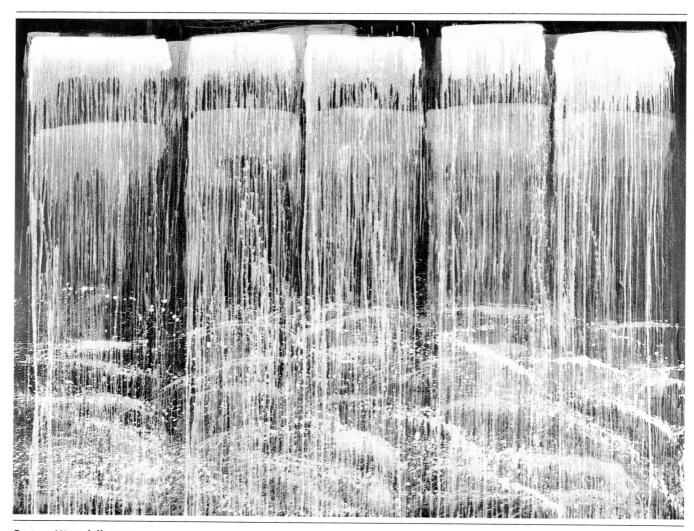

Eastern Waterfall, 1990
Oil on canvas, 78 x 102 in.
Photo, © Phillips/Schwab
Courtesy, Robert Miller Gallery, New York

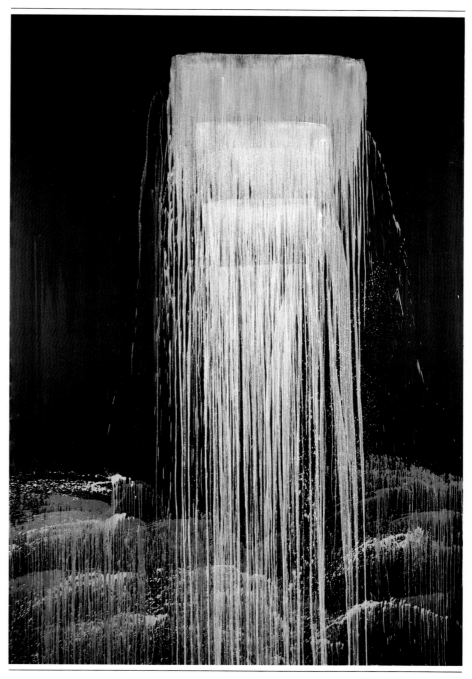

Peacock Waterfall, 1990
Oil on canvas, 179 x 121 in.
Photo, ©Phillips/Schwab
Courtesy, Robert Miller Gallery, New York

Idelle Weber

"The viewer's vision must be changed by a good Realist picture (or any picture). He or she should never be able to look at the subject depicted in the same way again."

Idelle Weber, working from photographs, will piece together fragmented views of architectural details, flower beds, a rock wall, a detail of a pond, even garbage in a gutter. The overall effect encourages the viewer to enter the scene on a level that is often missed in a more spectacular vista.

The symmetrical images of her gardens show a contrast between simultaneous naturalist and abstract-geometric tendencies. At first, the details seem executed in rigidly structured symmetry but behind this are complex conceptual references.

Her gift for color is seen in the way she orchestrates her hues; the water of the pond in *Pistia Kew* is both reflective and transparent. The vivid colors she uses are for the most part luminous with a rich and palpable clarity.

Idelle Weber's "trash pictures" were done with an artist's eye for color, form and content. The artist has helped the viewer wonder what kind of landscape modern man is creating for the generations to come.

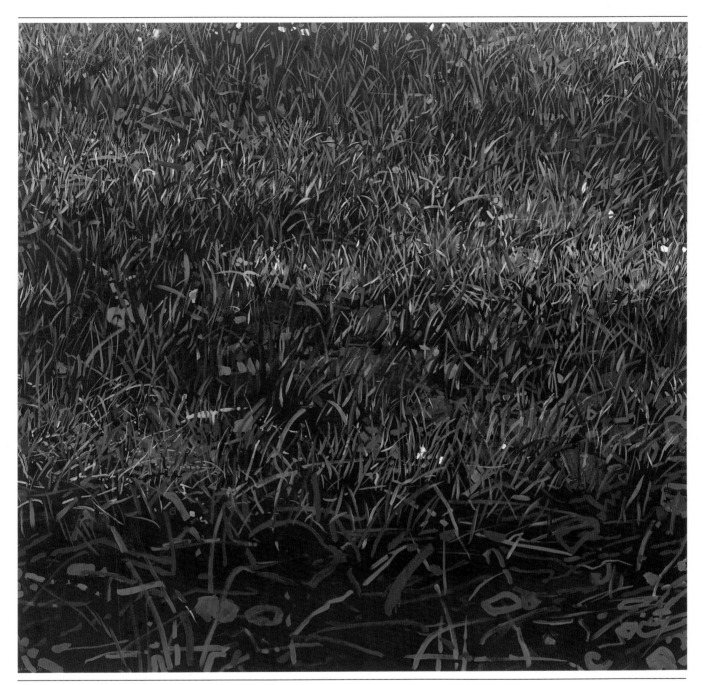

East End — Grass II (one of four panels), 1990
Oil on linen, 50 x 50 in.
Courtesy, Anthony Ralph Gallery

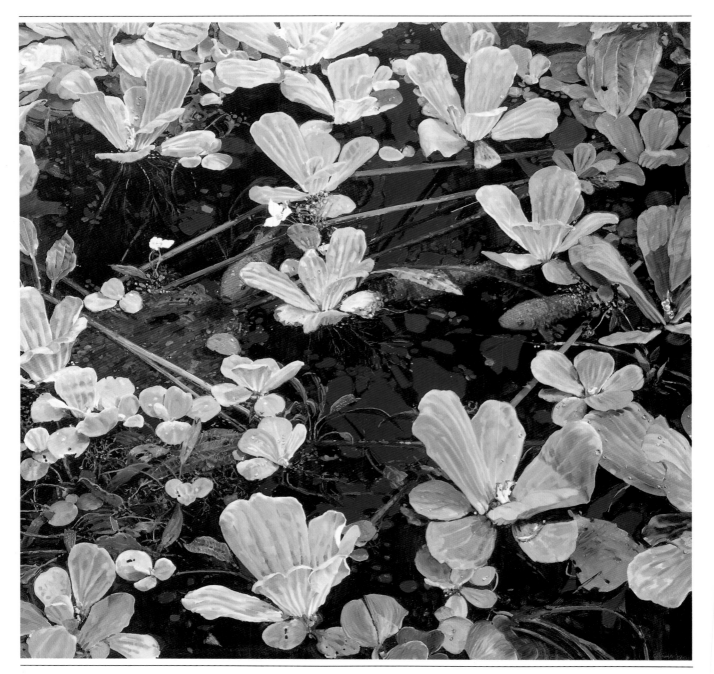

Pistia Kew, 1989
Oil on linen, 58 x 59 in.
Courtesy, Anthony Ralph Gallery

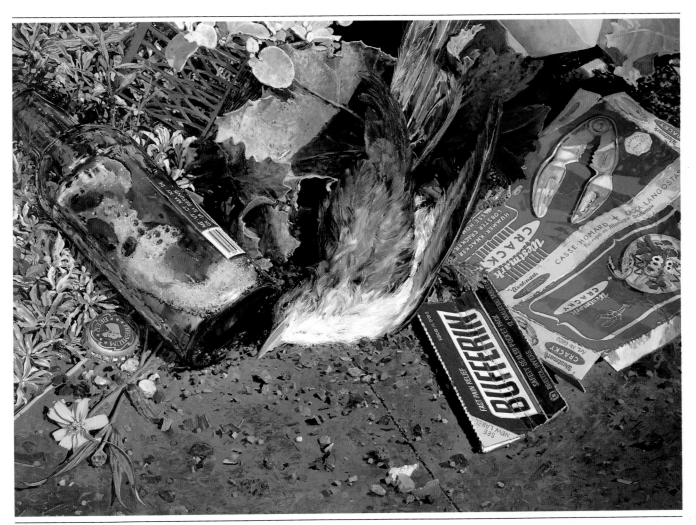

East End — Bufferin, 1990
Oil on linen, 50 x 65 in.
Courtesy, Anthony Ralph Gallery

Jane Wilson

Photo, ©Michael Leonard

Jane Wilson first painted abstract works but eventually she found her own voice in landscape, which became her primary subject from the mid-1950s to the mid-1960s. She is intrigued by pictures that have nothing to hang on to or that defy our assumptions about nature. Her landscapes are stripped of extraneous detail. The viewer is carried upward from the horizontal planes of land and ocean into the atmosphere. She has written, "The format of everything I do springs from our existence at the bottom of a rolling ocean of air."

Her pigments are chosen for their ability to evoke different colors. She has stated " . . . each color has a kind of inner light that becomes an active force in bringing about the imagery of the painting. The sky may be blue, but there is another kind of light and color illuminating it from behind. Investigating the color, light, weight and the movement of the atmosphere ultimately yielded the blue that was illuminated from behind. Any given color carries with it physical and emotional associations that are very strong and far outside the realm of words."

Always eager to learn and know, she has constantly explored the creative possibilities of her medium. In the '70s she started to investigate the still life. Wilson was intrigued by the relationships objects had with one another as well as with the space surrounding them.

Jane Wilson has said that she never knows what the image she creates is going to be, but she is willing to trust her intuition and feelings in its creation.

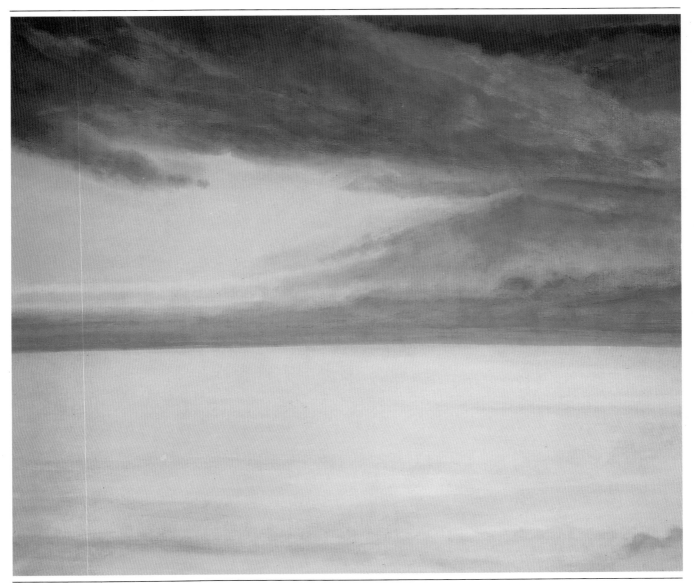

Solstice, 1991
Oil on linen, 60 x 70 in.
Courtesy, Fischbach Gallery, New York

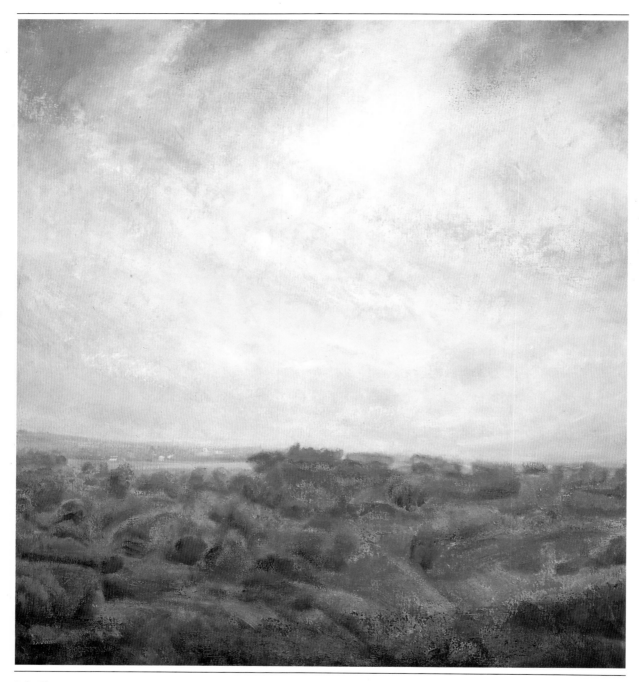

July Sky, 1983
Oil on linen, 60 x 55 in.
Courtesy, Fischbach Gallery, New York

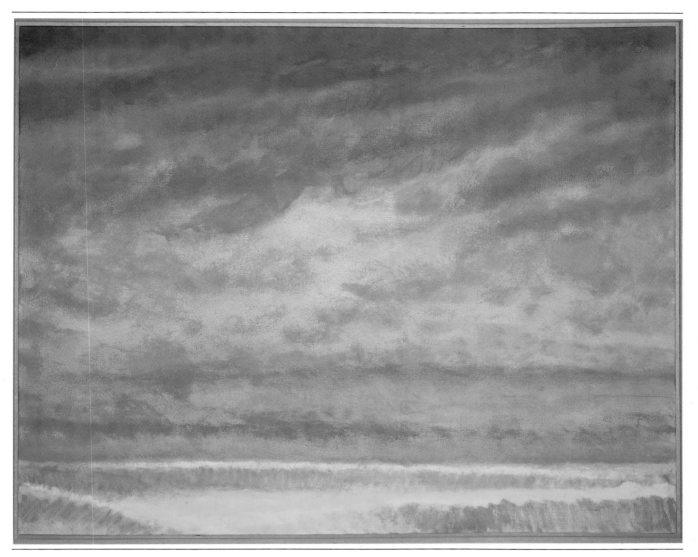

Winter Wheat, 1991
Oil on linen, 40 x 50 in.
Courtesy, Fischbach Gallery, New York

Jackie Winsor

Photo, ©Barbara Yoshida, 1991

"I'm just re-creating myself."

In 1979, after only twelve years spent as an artist, Jackie Winsor at age 37, was the youngest artist ever to have a major retrospective at the Museum of Modern Art in New York. In addition, she is the first woman whose work was represented in its sculpture garden.

In her early sculptures, Winsor used plaster and polyester resin mixed together with a variety of other man-made materials. These early abstract and geometric pieces embodied feelings of strength and mass that would grow more pronounced after she switched to natural materials. Her affinity to her materials derives from the harsh and barren landscapes and seascapes she remembers from her native Newfoundland.

With hammer and nails, wood and metal, concrete and brick, rope and glue, she builds objects that have pervading feelings of permanence.

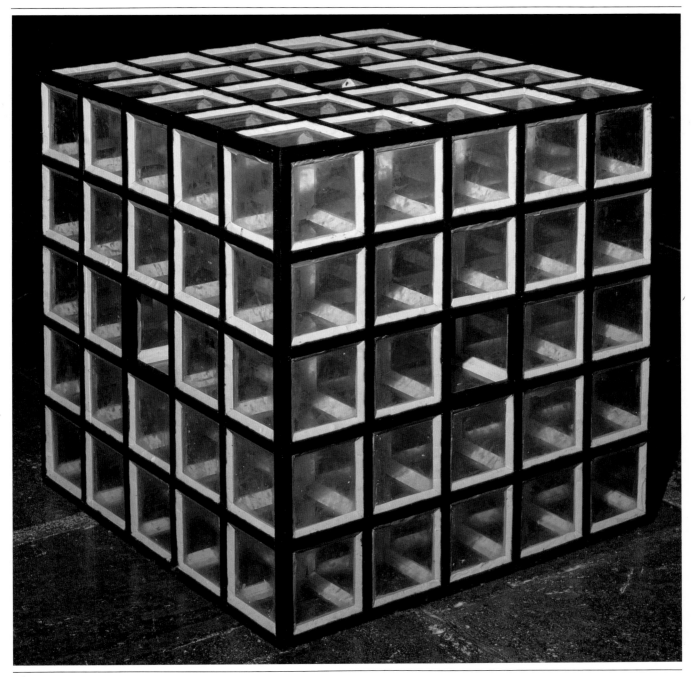

Glass Piece, 1978-79
Wood, glass and tar, 32 x 32 x 32 in.
Collection, Art Gallery of Ontario, Toronto
Courtesy, Paula Cooper Gallery, New York

Jackie Winsor

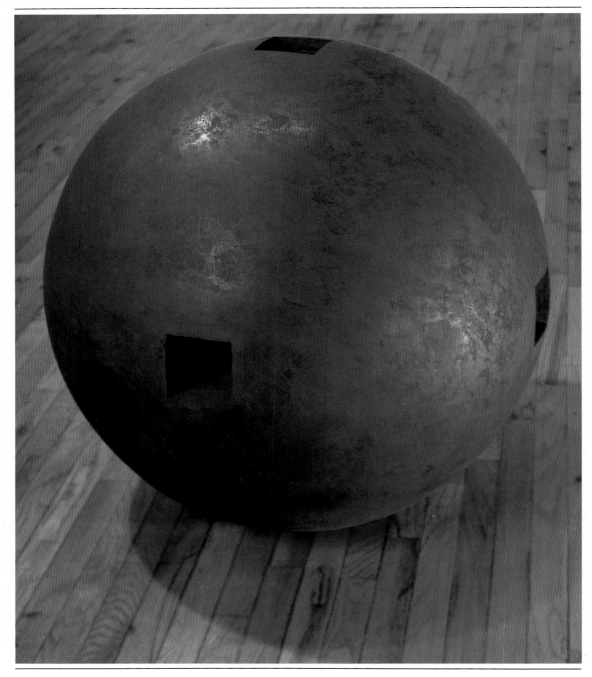

Blue Sphere, 1981-86
Concrete and blue pigment, 32 in. diameter
Photo, ©eeva-inkeri
Collection, The Rivendell Collection
Courtesy, Paula Cooper Gallery, New York

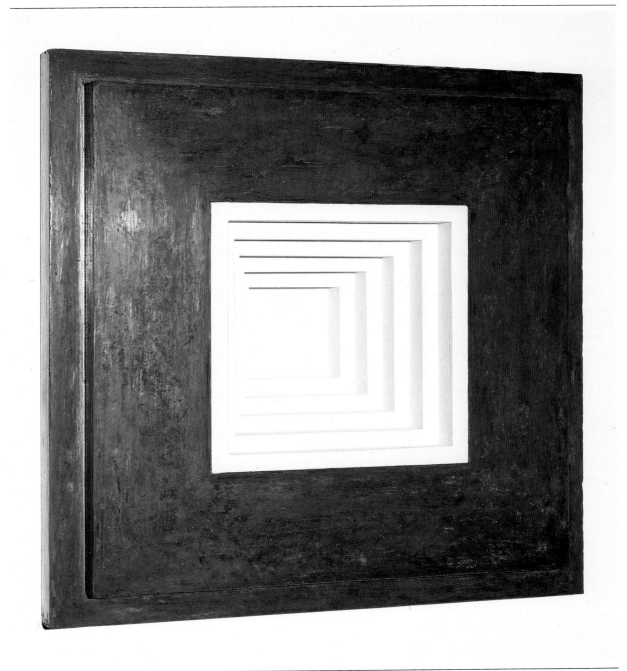

Inset Wall Piece with Stepped White Interior, 1988-89
Cement and pigment, 17 x 17 x 5¾ in.
Photo, © Geoffrey Clements
Collection, Martin Sklar, New York
Courtesy, Paula Cooper Gallery, New York

Biographies

All the women artists included in this book have careers spanning many years during which they have exhibited their works countless times. It is not possible within the limited confines of this book to more than briefly list a few of their professional accomplishments. It would, in fact, require a book for each artist to list her works, exhibits, awards, educational credentials and accomplishments fully. We hope that Contemporary American Women Artists *will encourage the reader to examine in greater depth the individual artists showcased here.*

JENNIFER BARTLETT

Born
Long Beach, CA, 1941

Education
1963 B.A., Mills College, Oakland, CA
1964 B.F.A., Yale School of Art and Architecture, New Haven
1965 M.F.A., Yale School of Art and Architecture, New Haven

Selected Solo Exhibitions
1991 Paula Cooper Gallery, New York
1990 Knoedler Gallery, London
1989 John Berggruen Gallery, San Francisco
 Knoedler Gallery, London
1986 The Cleveland Museum of Art, Cleveland
1985 Walker Art Center, Minneapolis

Selected Group Exhibitions
1990 Museum of Art, Rhode Island School of Design, Providence
 Norton Gallery of Art, West Palm Beach, FL
1989 Cincinnati Art Museum, Cincinnati
1988 Museum of Contemporary Art, Chicago
1987 Detroit Institute of the Arts, Detroit
1986 The Art Institute of Chicago, Chicago
1985 The Hudson River Museum, Yonkers, NY
1984 Museum of Fine Arts, Boston

LYNDA BENGLIS

Born
Lake Charles, LA, 1941

Education
1964 B.F.A., Newcomb College, New Orleans

Selected Solo Exhibitions
1990 Paula Cooper Gallery, New York
 Richard Gray Gallery, Chicago
1989 Tilden-Foley Gallery, New Orleans

1988 Fuller Gross Gallery, San Francisco
1987 Margo Leavin Gallery, Los Angeles
1986 Fuller Goldeen Gallery, San Francisco
1985 Dart Gallery, Chicago
1984 The Texas Gallery, Houston

Selected Group Exhibitions
1990 Whitney Museum of American Art, New York
 Jan Kesner Gallery, Los Angeles
1989 Baltimore Museum of Art, Baltimore
 New Orleans Museum of Art, New Orleans
1988 Mayor Rowan Gallery, London
1987 Solomon R. Guggenheim Museum, New York
 The Nelson-Atkins Museum of Art, Kansas City, MO
1986 Museum of Modern Art, New York
 Philadelphia Museum of Art, Philadelphia
1985 Helander Gallery, Palm Beach

LOUISE BOURGEOUIS

Born
Paris, France, 1911

Education
1932-35 Sorbonne, Paris
1936-37 Ecole du Louvre
1936-38 Ecole des Beaux-Arts
1936-37 Atelier Bissiere
1937-38 Academie de la Grande Chaumiere
1938 Fernand Leger
1939-40 Vaclav Vytlacil

Selected Solo Exhibitions
1991 Galerie Lelong, Zurich
1990 Karsten Greve Gallery, Cologne
1988 Robert Miller Gallery, New York
1985 Serpentine Gallery, London
1982-83 Museum of Modern Art, New York

Selected Group Exhibitions
1991 The Carnegie Museum of Art, Pittsburgh
 Museum of Modern Art, New York
1989 Centre Georges Pompidou, Paris
1986-87 Bernice Steinbaum Gallery, New York
1985 Hill Gallery, Birmingham, MI

DEBORAH BUTTERFIELD

Born
San Diego, CA, 1949

Education

1972 Skowhegan School of Painting and
 Sculpture, ME
1972 B.F.A., University of California at Davis,
 Davis, CA
1973 M.F.A., University of California at Davis,
 Davis, CA

Selected Solo Exhibitions

1990 Carlson Gallery, University of Bridgeport,
 Bridgeport, CT
1989 Zolla/Liberman Gallery, Chicago
 Gallery Paule Anglim, San Francisco
1988 The Faith & Charity in Hope Gallery,
 Hope, ID
1987 Edward Thorp Gallery, New York
1985 Fuller Goldeen Gallery, San Francisco
1983 Chicago Cultural Center, Chicago
1982 Mayor Gallery, London

Selected Group Exhibitions

1989 Pennsylvania Academy of the Fine Arts,
 Philadelphia
 The Hudson River Museum, Yonkers, NY
 Whitney Museum of American Art at
 Equitable Center, New York
1987 National Sculpture Society, Port of History
 Museum, Philadelphia
1985 Nicola Jacobs Gallery, London

LOUISA CHASE

Born

 Panama City, FL, 1951

Education

1971 Yale University School of Art, New Haven
1973 B.F.A., Syracuse University, Syracuse, NY
1975 M.F.A., Yale University School of Art,
 New Haven

Selected Solo Exhibitions

1991 Brooke Alexander, New York
1989 Mira Godard Gallery, Toronto
1986 Robert Miller Gallery, New York
1985 Margo Leavin Gallery, Los Angeles
1984 The Institute of Contemporary Art, Boston

Selected Group Exhibitions

1990 Daimaru Exhibition Hall, Osaka
1989 Cincinnati Art Museum, Cincinnati
1988 Metropolitan Museum of Art, New York
1987 Yale University Art Gallery, New Haven
 Baltimore Museum of Art, Baltimore
1985 Whitney Museum of American Art,
 New York

1984 The Brooklyn Museum, Brooklyn
 San Francisco Museum of Modern Art,
 San Francisco
1983 The Museum of Modern Art, New York
1982 Whitney Museum of American Art,
 New York
1980 Indianapolis Museum of Art, Indianapolis

JANET FISH

Born

 Boston, MA, 1938

Education

1960 B.A., Smith College, Northampton, MA
1961 Skowhegan Art School, Skowhegan, ME
1963 B.F.A. and M.F.A., Yale University School
 of Art and Architecture, New Haven, CT

Selected Solo Exhibitions

1991 Robert Miller Gallery, New York
 Carlson Gallery, University of Bridgeport,
 Bridgeport, CT
1990 Brevard Art Center and Museum,
 Melbourne, FL
 Linda Cathcart Gallery, Santa Monica, CA
1986 Smith College, Northampton, MA
1984 Columbia Museum of Art, Columbia, SC

Selected Group Exhibitions

1991 National Academy of Design, New York
1990 Sherry Franch Gallery, New York
1989 Taft Museum, Seattle
1987 American Academy Institute of Arts and
 Letters, New York
1985 Wichita Art Museum, Wichita, KS

AUDREY FLACK

Born

 New York City, 1931

Education

1952 B.F.A., Yale University, New Haven, CT
1953 Institute of Fine Arts, New York University,
 New York

Selected Solo Exhibitions

1991 Louis K. Meisel Gallery, New York
1987 Alexander Brest Museum, Jacksonville
 University, Jacksonville, FL
 Gallery of Fine Art, Ohio State University,
 Columbus
1986 Atlantic Center for the Arts,
 New Smyrna Beach, FL

1984	Hewlett Art Gallery, College of Fine Arts, Carnegie-Mellon University, Schenley Park, PA
1983	Armstrong Gallery, New York
1981	Fine Arts Gallery, University of South Florida, Tampa, FL

Selected Group Exhibitions

1990	Samuel P. Harn Museum of Art, University of Florida, Gainesville, FL
	Haggerty Museum of Art, Marquette University, Milwaukee, WI
1989	New Orleans Museum of Art, New Orleans
1988	Louis K. Meisel Gallery, New York
	The Queens Museum, Flushing, NY
1987-88	National Portrait Gallery, Smithsonian Institution, Washington
1987	Elaine Benson Gallery, Bridgehampton, NY
1986	Whitney Museum of American Art, New York
	Metropolitan Museum of Art, Colorado Springs Fine Arts Center, CO
1985-86	Beaux Arts Collectors Gallery, Columbus Museum of Art, Columbus
1984	Museum of Modern Art, Chrysler Building, New York

JANE FREILICHER

Born

Brooklyn, NY, 1924

Education

1947	B.A., Brooklyn College, Brooklyn, NY
1948	M.A., Columbia University, New York

Selected Solo Exhibitions

1990	Fischbach Gallery, New York
	Heath Gallery, Atlanta
1986-87	The Currier Gallery of Art, Manchester, NH
	The Parrish Art Museum, Southampton, NY
	Contemporary Arts Museum, Houston
	McNay Art Museum, San Antonio, TX
1983	Kansas City Art Institute, MO
1979	Utah Museum of Fine Arts, Salt Lake City

Selected Group Exhibitions

1991	National Academy of Design, New York
	Smith College Museum of Art, MA
	Philbrook Museum of Art, Tulsa, OK
1990	The Chrysler Museum, Norfolk, VA
1989	The American Academy and Institute of Arts and Letters, New York
	Memorial Art Gallery, Rochester, NY
1988	Rice University, Houston
	Weatherspoon Art Gallery, Greensboro, NC

1987	The Bayly Art Museum, Charlottesville, VA
1986	Contemporary Arts Center, New Orleans
	The Butler Institute of American Art, OH

VIOLA FREY

Born

Lodi, CA, 1933

Education

1952-53	Stockton Delta College, Stockton, CA
1953-56	B.F.A., California College of Arts and Crafts, Oakland, CA
1956-58	M.F.A., Tulane University, New Orleans

Selected Solo Exhibitions

1990	Rena Bransten Gallery, San Francisco
1989	Nancy Hoffman Gallery, New York
1988	Asher/Faure Gallery, Los Angeles
1984	Whitney Museum of American Art, New York

Selected Group Exhibitions

1989	La Foret Museum, Koto-ku, Japan
1988	Walter Phillips Gallery, The Banff Centre, The School of Fine Arts, Banff, Alberta, Canada
	The Queens Museum, Flushing, NY
1987	American Center, Paris
1985	The Oakland Museum, Oakland, CA

YVONNE JAQUETTE

Born

Pittsburgh, PA, 1934

Education

1952-56	Rhode Island School of Design, Providence

Selected Solo Exhibitions

1991	John Berggruen Gallery, San Francisco
1990	Brooke Alexander, New York
1988	Brooke Alexander, New York
1986	Barbara Krakow Gallery, Boston
1983	St. Louis Art Museum, St. Louis

Selected Group Exhibitions

1990	The Katonah Gallery, New York
1989	Whitney Museum of American Art, New York
	Baltimore Museum of Art, Baltimore
1987	Virginia Museum of Fine Arts, Richmond, VA
1986	The Brooklyn Museum, Brooklyn

| 1984 | The Museum of Modern Art, New York |
| 1982 | Nelson-Atkins Museum of Art, Kansas City, MO |

MARISOL

Born

Paris, 1930

Education

1949	Ecole des Beaux Arts, Paris
1950	The Arts Students League, New York
1951-54	The New School, New York

Selected Solo Exhibitions

1991	National Portrait Gallery, Washington
1989	Sidney Janis Gallery, New York
	Galerie Tokoro, Tokyo
1988	Boca Raton Museum of Art, Boca Raton, FL
	Dolly Fiterman Gallery, Minneapolis

Selected Group Exhibitions

1991	Anne Plumb Gallery, New York
1990	The National Museum of Contemporary Art, Seoul, Korea
1989	Southern Alleghenies Museum of Art, Loretto, PA
	Hillwood Art Gallery, Long Island University, Brookville, NY
1985	Philadelphia Art Museum, Philadelphia
1984	Hirshhorn Museum and Sculpture Garden, Washington

JOAN MITCHELL

Born

Chicago, IL, 1926

Education

1942-44	Smith College, Northampton, MA
1947	B.F.A., The Institute of Chicago, Chicago
1950	Columbia University, New York
1950	M.F.A., The Art Institute of Chicago, Chicago

Selected Solo Exhibitions

1991	Robert Miller Gallery, New York
1990	Galerie Jean Fournier, Paris
1988-89	Herbert F. Johnson Museum of Art, Cornell University, Ithaca, NY
1984	Keny and Johnson Gallery, Columbus, OH
1982	Musee d'Art Moderne de la Ville de Paris, Paris

Selected Group Exhibitions

| 1991 | Whitney Museum of American Art, New York |
| | National Academy of Design, New York |

1990-91	The Museum of Modern Art, New York
1988	The Parrish Art Museum, Southampton, NY
1987	Museum of Fine Art, Richmond, VA
1985	National Museum of American Art, Smithsonian Institution, Washington

ELIZABETH MURRAY

Born

Chicago, IL, 1940

Education

| 1962 | B.F.A., Art Institute of Chicago, Chicago |
| 1964 | M.F.A., Mills College, Oakland, California |

Selected Solo Exhibitions

1990	John Berggruen Gallery, San Francisco
	Paula Cooper Gallery, New York
1989	Gallery Mukai, Tokyo
	Greg Kucera Gallery, Seattle
1988	San Francisco Museum of Modern Art, San Francisco
	Daniel Weinberg Gallery, Los Angeles

Selected Group Exhibitions

1990	American Academy and Institute of Arts and Letters, New York
	The Museum of Modern Art, New York
	Germans van Eck Gallery, New York
1989	The Albuquerque Museum, Albuquerque

ADRIAN PIPER

Born

New York City, 1948

Education

1966-69	A.A., School of Visual Arts, New York
1970-74	B.A., City College of New York, New York
1974-77	M.A., Harvard University, Cambridge, MA
1981	Ph.D., Harvard University, Cambridge, MA

Selected Solo Exhibitions

1990	Whitney Museum of American Art, New York
1989	John Weber Gallery, New York
1987	The Alternative Museum, New York
1981	And/Or, Seattle
1980	Wadsworth Atheneum, Hartford, CT

Selected Group Exhibitions

1991	John Weber Gallery, New York
1990	Wexner Center for the Visual Arts, Ohio State University, Columbus
	Contemporary Arts Center, Buffalo, NY

1989	Cincinnati Art Museum, Cincinnati
1988	Maryland Institute of Art, Baltimore
	Whitney Museum Downtown, New York
1985	The Studio Museum in Harlem, New York
1983	The New Museum, New York

FAITH RINGGOLD

Born

New York City, 1930

Education

1955	B.S., City College of New York, New York
1959	M.A., City College of New York, New York

Selected Solo Exhibitions

1990	Fine Arts Museum of Long Island, Hempstead, NY
1989	Fine Arts Center, University of Massachusetts at Amherst, Amherst, MA
1988	Bernice Steinbaum Gallery, New York
1987	Baltimore Museum of Art, Baltimore
1983	Lehigh University, Bethlehem, PA

Selected Group Exhibitions

1990	Contemporary Arts Center, New Orleans
1989	Axis Twenty, Inc., Atlanta
	Cincinnati Art Museum, Cincinnati
	Nexus Gallery, Philadelphia
1988	Museum of Modern Art, New York
	Metropolitan Museum and Art Center, Coral Gables FL
1987	Virginia Museum of Art, Richmond, VA
	The National Portrait Gallery, Washington
1985	United Nations International Conference on Women, Nairobi, Kenya
	The Newark Museum, Newark, NJ

DOROTHEA ROCKBURNE

Born

Montreal, Québec

Education

Black Mountain College

Selected Solo Exhibitions

1991	André Emmerich Gallery, New York
1989	Rose Museum, Brandeis University, Waltham, MA
1988	André Emmerich Gallery, New York
1987	Arts Club of Chicago, Chicago
1986	Xavier Fourcade, New York
1983	Galleriet, Lund, Sweden
	Galleria Toselli, Milan
1980	Museum of Modern Art, New York

Selected Group Exhibitions

1991	Margo Leavin Gallery, Los Angeles
1990	Nohra Haime Gallery, New York
	Hood Museum of Art, Dartmouth College, Hanover, NH
	Francis Graham-Dixon Gallery, London

MIRIAM SCHAPIRO

Born

Toronto, Ontario, 1923

Education

1945	B.A., State University of Iowa, Iowa City
1946	M.A., State University of Iowa, Iowa City
1949	M.F.A., State University of Iowa, Iowa City

Selected Solo Exhibitions

1991	Brevard Art Center and Museum, Melbourne, FL
1990	Lew Allen/Butler Fine Art, Santa Fe
1987	Simms Fine Art Gallery, New Orleans
	Gibbes Art Gallery, Charleston
1986	Bernice Steinbaum Gallery, New York
1984	Atlanta Center for the Arts, New Smyrna Beach, FL
	Dart Gallery, Chicago
1983	Barbara Gilman Gallery, Miami, FL
1982	Barbara Gladstone Gallery, New York

Selected Group Exhibitions

1991	Weatherspoon Art Gallery, Greensboro, NC
1989	Cincinnati Art Museum, Cincinnati
1988	Museum of Modern Art, New York
	Houston Museum of Fine Arts, Houston
1987	Boston University Art Gallery, Boston
1985	American Academy and Institute of Arts and Letters, New York
1984	The Bruce Museum, Greenwich, CT
	Suzanne Gross Gallery, Philadelphia

CINDY SHERMAN

Born

Glen Ridge, NJ, 1954

Education

1976	B.A., State University College, Buffalo, New York

Selected Solo Exhibitions

1991	Milwaukee Art Museum, Milwaukee
	Basel Kunsthalle, Basel, Switzerland
1990	Padiglione d'arte contemporanea, Milan
1989	Metro Pictures, New York
	Galerie Pierre Hubert, Geneva

1987 Galerie Crousel-Robelin, Paris
 The Whitney Museum of American Art, New York

Selected Group Exhibitions
1990 Museum of Modern Art, New York
 The Stedelijk Museum, Amsterdam
1989 Victoria and Albert Museum, London
 The Vienna Festival, Vienna

ALEXIS SMITH

Born
 Los Angeles, CA, 1949

Education
1970 B.A., University of California at Irvine.

Selected Solo Exhibitions
1991 Mandeville Gallery, La Jolla, CA
1990 Margo Leavin Gallery, Los Angeles
 Josh Baer Gallery, New York
1987-88 The Brooklyn Museum, Brooklyn
1986 Institute of Contemporary Art, Boston
 Walker Art Center, Minneapolis
1981 Los Angeles County Museum of Art, Los Angeles

Selected Group Exhibitions
1990 Milwaukee Art Museum, Milwaukee
1989-90 Whitney Museum of American Art, New York
1989 Cincinnati Art Museum, Cincinnati
1986-87 Long Beach Museum of Art, Long Beach, CA
1986 The Corcoran Gallery of Art, Washington
1984 Queens Museum, Flushing, NY

JAUNE QUICK-TO-SEE SMITH

Born
 Montana

Education
 B.A., Framingham State College, MA
 M.F.A., University of New Mexico, New Mexico

Selected Solo Exhibitions
1987 Bernice Steinbaum Gallery, New York
 Marilyn Butler Gallery, Santa Fe
1986 Yellowstone Art Center, Billings, Montana
1985 Bernice Steinbaum Gallery, New York
 Marilyn Butler Gallery, Santa Fe
1984 University of Missouri, St. Louis

Selected Group Exhibitions
1987 Chrysler Museum, Norfolk, VA
 Fort Wayne Museum of Art, Fort Wayne, IN
1986 Bernice Steinbaum Gallery, New York
1985 Bruce Museum, Greenwich, CT

PAT STEIR

Born
 Newark, NJ, 1940

Education
1958-60 Boston University, Boston, MA
1961 B.F.A., Pratt Institute, Brooklyn, NY

Selected Solo Exhibitions
1991 Linda Cathcart Gallery, Santa Monica, CA
1990 Robert Miller Gallery, New York
 Galerie Montenay, Paris
 Victoria Miro Gallery, London
1988-89 Cabinet des estampes, Musee d'Art et d'Historie, Geneva
1987 The New Museum of Contemporary Art, New York
 Rijkmuseum Vincent Van Gogh, Amsterdam
1986-87 Dallas Museum of Art, Dallas
1984-85 Brooklyn Museum, Brooklyn

Selected Group Exhibitions
1991 Whitney Museum of American Art, New York
1990 Ecole Des Beaux Arts, Tourcoing, France
 Baltimore Museum of Art, Baltimore
1987 The Harcus Gallery, Boston
1986-87 Boston Museum of Fine Arts, Boston
1986 Santa Barbara Museum of Art, Santa Barbara
1984-85 Hirshhorn Museum and Sculpture Garden, Smithsonian Institution, Washington

IDELLE WEBER

Born
 Chicago, 1932

Education
1950-51 Scripps College, Claremont, CA
1954 B.A., University of California, Los Angeles
1955 M.A., University of California, Los Angeles

Selected Solo Exhibitions
1991 Anthony Ralph Gallery, New York
1988 Squibb Gallery, Princeton, NJ
1987 Ruth Siegel Ltd., New York
1986 Arts Club of Chicago, Chicago
1982 O.K. Harris Works of Art, New York

Selected Group Exhibitions
1991	Whitney Museum of American Art at Stamford, Stamford, CT
1990	New Museum of Contemporary Art, New York
1989	Jacksonville Art Museum, Jacksonville, FL
1988	Richard Green Gallery, New York
1986	Indianapolis Museum of Art, Indianapolis
1985	San Francisco Museum of Modern Art, San Francisco
1984	Adams-Middleton Gallery, Dallas
1983	Louis K. Meisel Gallery, New York

JANE WILSON

Born

Seymour, IA, 1924

1945	B.A., University of Iowa, Iowa City
1947	M.F.A., University of Iowa, Iowa City

Selected Solo Exhibitions
1991	Dartmouth College, Hanover, NH
1990	Fischbach Gallery, New York
	University of Richmond, VA
1989	American University, Washington, D.C.
1988	Compass Rose Gallery, Chicago
1982	Cornell University, Ithica, NY

Selected Group Exhibitions
1991	National Academy of Design, New York
	Pennsylvania Academy of the Fine Arts, Philadelphia
	American Academy and Institute of Arts and Letters, NY
1989	Tampa Museum of Art, FL
1988	Weatherspoon Art Gallery, Greensboro, NC
1987	The Bayly Art Museum, Charlottesville, VA
	The University of Massachussetts, Amherst, MA
1986	University of Northern Iowa, Cedar Falls, IA
	Orlando Museum of Art at Loch Haven, FL

JACKIE WINSOR

Born

St. John's, Newfoundland, 1941

Education
1964	Yale Summer School of Art and Music, New Haven
1965	B.F.A., Massachusetts College of Art, Boston
1967	M.F.A., Rutgers University, New Brunswick, NJ

Selected Solo Exhibitions
1989	Paula Cooper Gallery, New York
1988	Centre d'Art du Domaine de Kerguehennec Bignan, Locmine, France
1987	Margo Leavin Gallery, Los Angeles
1986	Paula Cooper Gallery, New York

Selected Group Exhibitions
1990	Daniel Weinberg Gallery, Santa Monica, CA
1989	Judy Youens Gallery, Houston
	Cincinnati Art Museum, Cincinnati
	Whitney Museum of American Art, New York
1987	Bell Gallery, List Art Center, Brown University, Providence, RI
	The Contemporary Arts Center, Cincinnati
1985	Boston Museum of Fine Arts, Boston

Selection
Committee

In the selection of these twenty-four women artists, we enlisted the help of a special committee of six art professionals. Each committee member is recognized for her or his wide range of knowledge of contemporary art which was invaluable during the artist selection process. We wish to acknowledge and thank each of them for their participation in the difficult task of choosing the artists highlighted in this book.

JOHN CHEIM

Artist, Alex Katz

John Cheim studied painting and photography at the Rhode Island School of Design where he graduated in 1977. In that year he began working with the newly formed Robert Miller Gallery and in 1982 became the gallery's director. He has organized exhibitions of and books about Louise Bourgeois, Alice Neel, Joan Mitchell, Janet Fish, Lee Krasner and Eva Hesse.

DIANA BURGESS FULLER

Diana Fuller was educated at Dominican College in San Rafael, California and studied Art History at the Sorbonne in Paris. She was owner and director of the Fuller Gallery from 1964 to 1990 and is currently the owner and director of Arts Enterprises, which specializes in consultation and production for special artists' projects. Diana Fuller has served on the Board of Trustees of the San Francisco Art Institute since 1980. In addition she has been on the boards of many of the San Francisco Bay Area's most innovative and influential art organizations, among these, The Headlands Center for the Arts and the Bay Area Coalition of Visual Arts.

Since 1978, she has also been involved with the Squaw Valley Community of Writers and has directed the administrative section of its Screenwriting Program for the last eleven years.

JOANNE D. ISAAC

Joanne D. Issac earned her B.F.A. in 1978 from Temple University's Tyler School of Art and an M.F.A. in painting from City University of New York, Hunter College in 1989. After graduating, Joanne Isaac went to work for the Bernice Steinbaum Gallery, which was then the only mainstream gallery in New York City that represented the work of women artists equally with those of men. As an archivist for a number of artists represented by the gallery, she has the pleasure of both viewing their work and being a participant in their careers. She often functions as the arbiter between the gallery director and the artists as well as coordinating publicity campaigns for each artist. Among the artists she works with are Miriam Schapiro and Faith Ringgold.

ANNE KOHS

Anne Kohs graduated Magna Cum Laude from California State University, San Francisco in 1973. She received her Master of Arts and a Distinguished Achievement Award from San Francisco State University in 1979. Anne Kohs, currently President of Anne Kohs & Associates, Inc., is an art historian and has extensive experience as a Business Advisor and Consultant in the visual arts. Her company works with a broad range of clients, including artists, museums, galleries, publishers, and corporations. Her work with corporations has included advising about the creation of corporate art collections, development and implementation of programs for the management of these collections, and advising about the formation of a corporate-sponsored cultural arts center. Anne Kohs has also served as a member of the board of directors for numerous non-profit organizations in the United States.

GAYLE MAXON

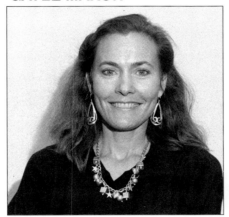

Gayle Maxon is Curator and Director of Contemporary Art at the Gerald Peters Gallery, Santa Fe, New Mexico.

Her professional associations include: Contemporary Art Society, Albuquerque, New Mexico; Art Table Inc., a national organization for professional women in the visual arts, New York and Advisory Board member for the Council for Art of the West, Museum of Fine Arts, Santa Fe, New Mexico.

In addition, she is also a voluntary assistant for the Festival of the Arts as well as the Western States Biennial Exhibition for Santa Fe.

NEIL WINKEL

Neil Winkel is the Associate Director of the Fischbach Gallery in New York City. The Fischbach Gallery was founded in 1960 on the premise of "young American art for young American collectors." For more than a decade it exhibited a broad range of work, which helped to establish the careers of many of today's well known artists.

Mr. Winkel studied Fine Art and Business Administration at Carnegie-Mellon University in Pittsburgh, Pennsylvania. While at the campus he directed the University's Forbes Gallery, which he helped develop into a multi-media arts center. He was subsequently commissioned by Mellon Bank to write about elements of their photography collection in New York and London.

In recent years he has raised funds, within the art community, for numerous social causes including housing for the homeless, AIDS and civil rights. Mr. Winkel currently resides in Manhattan.

Photo Credits